BEZOAR
DELINQXENZ

BEZOAR
DELINQXENZ

MOCHU

"Or, for instance. What is the expediency of building a bridge over a river from the point of view of a trout?"

DEFINITELY MAYBE (1978),
ARKADY AND BORIS STRUGATSKY

CONTENTS

CORROSIVE GEOMETRIES	10
TERRIBLE MAPS	16
CREATURE SYNTAX	34
THE INCREDIBLE VEDIC CHILL OR A FOUL LUMP IN THE (ANT)ARCTIC	56
CANISTER OF FACES— AN ECSTATIC POSTSCRIPT TO THE LOSS OF CULTURAL SUPREMACY	76
MOLD OF A DANK CONSPIRACY	80

CORROSIVE GEOMETRIES

In a sort of manic reversal of the popular skulltopus trope, Leon Burp's troubles began with a cluster of acidic faces translucently gleaming through the suckers of tentacles. Vivid and arresting as the vision was, it was still hard to forget that a case of abduction waited for him at the surface. And like most recent events in his life, this incident too had several beginnings and endings, much like the bubble-like dynamism of these faces, hypnotic in their facile lightness. Conceding to their latent powers for psychological derangement, weak classifications would eventually label them as "gelatinous ammonia apparitions." All manner of disjointed expressions floated about: laughing, crying, hysterically shaking through

the deep-sea cold, before the tentacles disappeared into the plankton horizon.

Lodged between some black rocks by the seashore was the collapsed figure of the writer Dizazel Babyloneon. Locating the site in Goa itself had taken days. A careful comb-through by their local contacts was key to finding the weary man on time. Drenched in seawater, and almost frostbitten cold even in that tropical sun, the writer was mumbling unintelligible when found. His posture was striking too; he did not look fallen, nor did he seem washed ashore. He was lying down but was also strangely aloft. The peculiar extra-rational intent emanating from that poise made it somehow hard to even look at him. A crystalline crab, that's what came to mind. This man could just crawl away sideways, very, very rapidly. That familiar crustacean flair so masterfully described in his books... the publisher thought, distracted silly by the combination of sharp black rocks, tropical heat, and the strange utterances. All these thoughts seemed more plausible perhaps because he had read the guy's books at length before starting out on this borderline doom of a project. Back in the late '90s, when Burp first read him, Babyloneon had developed quite a cult following in the francophone literary scene, after introducing in his eponymous pulp novel the idea of the "Messianic Nest." The fast-paced action thriller had all the right ingredients, with a stolid military agent busy on the top-secret task of escorting a mysterious woman across the Central Asian deserts. Subject to a bizarre posthuman experiment, the woman was the pregnant host to a "swarming prophecy," an incubating nest in her uterus that would eventually hatch an invasive army of beings from the future whose fetal development had already begun to cause destabilizing effects on worldwide financial markets and the impending Y2K crisis. Aimed at some dystopic restructuring of human time-organization at large, the swarm's evolution was eagerly being monitored to cesium standards and tabbed by covert labs across the world. The blend of brutal political violence, mediocre science, and esoteric-mystical imagery, coupled with a mixtape writing style, had shot the writer to instant cult fame in his native Quebec, while also getting his

book banned in various countries due to its high currency in ultraviolet Christian fundamentalist clubs. Burp had picked up on the same thread; his publishing house needed exactly someone like this, who could revive their old texts to engage a younger readership, which basically meant young corporates, slaving away in white cubicles with no sense of their own politics. Babyloneon's online presence catching on fast under the acronym dB even highlighted the intoxicating appeal that his books held when "listened to" in groups, rather than simply read. Burp also remembered an old interview in some underground magazine; Babyloneon had traced the genealogy of the swarm pregnancy idea to a fragment from a medieval Hindu epic, where lumps of undifferentiated placental flesh from the royal family had been incubated in jars to breed a class of powerful human warriors predestined to fight an iconic political war. The intra-mythical connections were numerous, and fascinating enough as a base for Hormel Python Publishers to bring in Babyloneon to take part in their flamboyant museum pitch to the Indian government.

The abduction, however, had damaged the writer's memory considerably, or so it seemed. Concerned remarks about a kind of circus troupe dominated his recollections of the event. He claimed to have been enslaved for months, in a restless series of forced performances in public squares of some old European town, reminiscent of socialist Hungary, for reasons unknown. Although the circus performances seemed to have some durational, ritualistic quality, Babyloneon insisted on its technical nature, more like coding of some kind. He was sure that he was contributing to some programming or mining operation through those performances. Nevertheless, the dominance of dolphin masks in the circus indicated conspiracy trails of a different kind.

But even then, judging by the scale of absurdities seen of late in his own life, thought Burp, this fit in rather smooth. Notwithstanding that he still was grappling at a vocabulary to describe what he was facing. A whole complex of strategies had seemingly been deployed against him already: government directives, nagging neighbors, bad weather, food poisoning,

all at war with his new publishing efforts. He hadn't been able to send a single email, since a month. Things would slide into complete dysfunction as soon as he set out on the smallest of tasks related to the new publishing cycle. But there hadn't yet emerged any identifiable pattern either; everything and nothing was always, always wrong. Infrastructure in general was becoming sentient, and resisting the project. The overall atmosphere was Hitchcockian. The doors wouldn't shut, the fan wouldn't run, the taxi driver would be drunk; simple destinations became unreachable. And the horrific dreams. As if there was malice in every atom. Contemplatively playing with his iconic gray beard, DJ Hands Receivers had listened carefully to the problem, although the information wasn't sufficient for even him to interpret. In fact, Babyloneon's abduction came across as somewhat of a relief, given that a solid case of attack such as this was distinctive enough a rupture from the ambiguities of the previous weeks, and therefore enough to start off a proper investigation. Although by no means could the hospital reports be said to constitute any clue. Doctors sounded unsure about some decidedly "anomalous" bite at the back of Babyloneon's neck. Jellyfish bites weren't uncommon in Goa, if only in some seasons, but this seemed different. It was even hard to tell if Babyloneon's protracted hallucinations were a result of the bite. However, the real problem faced by the doctors wasn't the wound itself but the impossibility of examining it. Quite literally. In a strangely confused notification forwarded by the team of doctors, they had advised to keep Babyloneon under observation for an indefinite period of time, on the basis of the contagious potentials of an "unprecedented geometric factor" present in the wound. Days later, in a long overdue confession to his regional-language collaborators, Chariot Press, Burp recounted in terror the infernal lattice of shapes he saw in the hospital when he had a cursory glance at Babyloneon's wound. Like an overheated metal tube, his mind was getting twisted over softly, as if some latent synaesthesia got activated, as the excessive geometry bubbled over onto him. In the absence of any evident actant, it was a direct recognition of

abstract spatial complexity, without interference from any physical matter as such. In other words, the wound somehow seemed antecedent to the body that hosted it. Doctors wearing goggles had to drag Burp out of the room, to rescue him from the fugue-like state that followed this strange encounter. As the effect of the wound began to wear off, he wondered if his perceptive faculties were in some way mirroring that geometry, thereby self-destructing or going off-kilter. But even the effulgence of that memory soon faded. Ranting now to the Chariot Press managers, all he was left with were crude verbal approximations.

Over the following weeks, the doctors prepared further physical descriptions of the wound. A notable quality, wholly apart from the psychological states effected on others, was the fact that it was impossible to tell if it was a recession or a protrusion on the body. Was it a cut or a growth? The incongruous crisscrossing of planes, curvatures, and cavities was all too visible even in X-rays and MRI scans. Each radiation session yielded different results, with risky observation conditions for the doctors to boot, most of them getting held up for hours in psychologically ambiguous states while examining the mad opticality emerging in the scan results. More sophisticated technical scrutiny would be impossible to organize in Goa, or elsewhere in India. The odd thing was, though, the writer himself seemed to be facing no active discomfort due to the wound, which in any case was a big relief for Burp since it was upon his invitation that the writer had traveled to India. Being located at the back of the neck, the wound was rather hard for Babyloneon to see, and the tactile feel of it was rather unremarkable. In general, the wound was quite imperceptible to him. Conjectural estimates by the doctors hinted at a possibly invasive tentacular assault by some as-yet-unknown cephalopod during Babyloneon's swim. In spite of this explanation not squaring up too well evidentially, the case went into rest for a short while.

But rather serendipitously, the Chariot Press managers were only too eager to agree with Burp's lament. They too had had it in the last months. New Age hipster tourists from

Varanasi camping at the office lobby, employees unable to leave home due to the magnetic thrill of streaming political news, a libidinous infestation of rats in the Gorakhpur warehouse, cargo trucks jammed under low highway bridges—these were the insurmountable logistical tremors experienced at their office. These too, over the last two months, matching closely the timeline of problems felt by Hormel Python Publishers. Stacks and stacks of their renowned *Yuge Yuge* periodicals were shredded to bits by the rodents and all office papers had begun to smell of pesticides after weeks of intensive use. The staff had started getting sick from microdosing on poison. The legendary press had all but ceased operations, their famous gods-studded building facade sprayed over with dorky psychedelic graffiti by the end of the previous week. Collaborations would not sustain in this manner for sure; they had already been through too many online meetings, reaching nowhere. The last ones went on for hours with none of the participants ever putting their videos on; just sounds of electric fans screeching across the computer microphones. City garbage dumps spilled over with religious magazine powder, with chewed-over rat pulp storming the town as deistic dust. By the time serious investigations began, the "Yuge Yuge Dumpster" had already become a colloquial curiosity.

TERRIBLE
MAPS

Interstellar Sociology and Out There Political Philosophy being Duur Matter's majors back in the nostalgic days of university had definitely had some import on the hectic schedule of extraordinarily secret missions he was being relentlessly assigned. Altered physical laws across wayward planets, star clusters, and metagalactic dust whorls were normally taken to be zones of interminable ontological lacunae while examining criminal cases, whereas, for him, these were opportunities to demonstrate acute mastery. Take, for instance, the buzzing cluster of beehives inside that giant whale in Hungary; it was evident that, when the man stared into the eye of the dead whale stored in the circus container,

the eye appeared alive and moving precisely because of the swarming millions nesting behind the glassy retina. They were hard at work, building their anti-dwelling swarm bomb. Never mind the fact that these weren't really bees. Under his microscope, in a bout of apophenic revelation, Matter had clearly seen the emoji faces of the insects, squeaky and sly in their unsettling frowns and smiles. The mob waiting for days in the gray fog of the gray town in the gray cold felt that ineffable closeness with the crawling mass of insects, an affinity so biased to the comic faces, miming their smiles their gestures, with the emojis just like their emotional upheavals all foggy all gray, awaiting their own terrifying repression about to soon rise up and swamp the town. But the dolphins had begun to dance, their rhythm keeping the maggotonous flymoticons at drumbeat distance away from violent eruption. All the while with the whale rolling its insect-filled eye, animating the compound sphere with shiny pieces of buzzing tissue. But what really transpired during the writer's abduction? Altered laws of science demanded investigative devices of a certain ingenuity to be able to break through the puzzles arising from conflicting cosmologies, as was the case here. Earworm hatchers, tremorbuzz shakeronics, contraband paracusia, incubus toenail-clipping sounds, and parasomnic breathing collections filled up Matter's audio investigation station when he analyzed the data on Dizazel Babyloneon's performances done during his abduction hours. The circus was makeshift yet skillfully elaborate, with melancholically oscillating trapeze figures, a zoo of minor animals, and a happy load of amorous clowns. Adding to the complex rhythmatics was the recurrent flight of the tent itself in the strong wind. However, the air would always remain foggy and claustrophobically static as soon as the abrupt gust subsided. Almost everyone ignored it, even as they dragged back the steadily tearing fabric. The overall cacophony of bodies and objects combined with the regulation of insect flight in and around the whale was—as concluded by Matter—what held the mob back from unleashing its fatally estranged impulses on its own little town. The performers with dolphin masks were central to the production of this

rupture, the decisive crack in an otherwise familiar storyline of provincial crack-up. The entire scenario was abduction-centric. Babyloneon felt the performance that he was forced to participate in was—while a direct affront to his personal liberty—a message of sorts, aimed at sabotaging his larger project with Hormel Python Publishers and Foundation Ꮭ. The dolphins and the whale, acting as a single unified entity, revealed themselves to be a formidable war machine poised for the crankiest of battles.

Duur Matter's job was simply to investigate, not to opine, but as the deeper psychological trenches of the case opened up, he wondered about fundamental physics, about how political ideas would need updation on par with space-time noncorrelations. Are diplomatic superpositions, spooky-politicians-at-a-distance, or dark parliaments ever going to become a thing? In order to appear historically relevant to himself, Duur Matter had to constantly arrange his personal artifacts and living space in a manner befitting the image of a classic film-noir secret agent. Even while no one was watching, he would often walk around the streets in scrupulous coat-and-hat attire, with a comfortably full pack of cigars in easy reach. Now, in the tropical boiler that was Goa, this looked profoundly otiose. And combined with the nonchalant acuity of his insights, such awfully nonessential gestures always kept his paychecks sufficiently high in comparison to his colleagues'. With the kind of technical arsenal at his disposal, always activated for instant use across multidimensional thresholds, there was usually nothing to worry about—but still this case was quite a mess.

Spectacular plans lurked beneath the niche facade of Hormel Python's publishing initiative. Spiritualist ideology, real estate geophagy, and post-hedonic perversion simmered like hymenopteran architecture caving the ground under. DJ Hands Receivers was the intellectual driver, and Leon Burp had been preparing the paperwork for Foundation Ꮭ in Goa, since many years now, in parallel with the rapidly expanding publishing efforts, based on the DJ's ideas. The imaginary underpinning their strategic grid was vast, with particular

interest in Hands Receivers' exhaustive rethinking of the role of South Asian pre-Axial religions in a trans-Eurasian context. In the mid-1990s, he had moved to Goa from Russia after the collapse of the Soviet Union, with some known past in occult rock groups critical of communism in general. However, in the early days in Goa, sporting a long gray beard, he was taken for somewhat of a digital shaman, a Russian Hakim Bey, so to speak, offering temporary bodily autonomy through noise music, clubbing around remote villages away from the common beachside party spots. The '90s party mood in Goa was usually quite a lot of neo-tribal arrangements aided by multimedia interventions: mega-speakers powered by multideck amplifiers, smoke machines, laser beams, and ultraviolet and stroboscopic lights with wonky video projections of fractals, industrial plants, hentai, declassified war footage, atomic mushroom trials, and cyber monsters, combined spatially with colorful drapes, tents, banners, psychedelic paintings, aromatic candles, incense, and local religious symbols like Om, the Shiva trident, and statues of Buddha or Ganesha. All set on loop and powered at the chemical level by a good supply of humidity, ecstasy, and hashish. Noise music was never a thing in these circles. Hands Receivers' sound acts were difficult to dig, even for the narrow circle of dedicated initiates who began to get drawn to it at first. The general ambience was designed with an air of metaphysical gloom. Over time, word got around and the cult value caught on. In an extraordinarily odd gesture, though, Hands Receivers soon began to discourage the use of drugs in his sessions, although not too strictly, given that it was the mainstay of the Goan party scene at large. But not only did this not interrupt good clubbing, the crowd found themselves the next day with refreshingly wild hangovers. Turning out to be some form of audio poisoning, this earned notoriety rather rapidly, with headaches integrated into an incessant stream of noisy theory on radical Eurasianism that wouldn't stop relaying for days in the ears of the partygoers. The lesser the drug intake, the clearer the streaming. And further defying all expectations, the partygoers were hooked immediately to the experience, with an inexplicable addiction to the Eurasian cause.

Posters and reading groups popped up, with lightly unhinged sloganeering on the streets. Local politicians were amused, attributing the capricious political enthusiasm to the newer stocks of MDMA circulating about. Reports from clubbers indicated that they had strong feelings, or "seminar-flavored convictions," that they owned the theories, that these weren't being streamed but actually thought out afresh by them. Never mind that the point contradicted their own addiction to regularly attending Hands Receivers' acts, without which these "own theories" would actually stop. It was an endlessly looping high of noise academia, soon referred to as JSCORing, parodying the paywalled online platform JSTOR that restricted access to academic publications.

Poststructuralist writing of the time had championed emerging rave and techno culture as an extended form of media utopianism integrated with cosmopolitanism, with the raving body as a kind of liberated site freed of superstructural restrictions. Easy comparisons mapped Artaudian Body without Organs (BwO), Deleuzo-Guattarian planes of immanence, and Batesonian plateaus onto a synthetic merger of comforting traditional music with the electronic alienation of techno, together producing a visceral explosion of unifying virtuality and inanimate disorganization characteristic of the electric waves traversing beachside dance floors. Shiva Trance. OmdruidZ. Mistletoejamachines. Sufi Tardigrades. Chillum Beatbox Exhalation Grind. Baba Chthonix Nihil Acoustica. Limbs flew apart. Sight, smell, hearing, taste, and touch all swarmed about as minor particles, nails and hair all waves, sexual fluids launched on antigravity trajectories merged with hair dyes, eyeshadows, nail polishes, and lip glosses. Spherical bodies, stick faces, and spit tentacles. Clique-fucq at the speed of teqqno-sweat. Organs shot out of Earth with musical engine propulsion. In somewhat of a crookedly dark variation, Hands Receivers had his party crowd grooving as Theory without Organs (TwO), a lethally deregulated state of bodily crack-up, open to the diagramming of theory as an uncontrollable post-organicist extremophilia, characterized by superconductive acceleration into throbbing political mastery.

The very strategies of techno that promised a dyscognitive escape velocity from the wrangling claws of metanarratives were parasitically infiltrated for their libidinal charge and intoxicating properties to incubate a cultural militarism with regressive biopolitical horizons. Becoming TwO was a kind of mithridatism, a protracted immunological program that would turn extreme dancers into antivenom *academons* through a controlled administering of audio poisons. Without encountering any final neutralization, the TwO extremophiles traversed an *esoterrain*, a continuous militant plateau of esoteric theory operations that never crescendo into war. For instance, although completely clean of any substance use, Hands Receivers' early acts such as Vishkanyandroid conjoined the chemical prosthesis engineering of legendary poison girls with the subversive fangs of theory to activate a serpentine regurgitation of ancient political assassination treatises. Concomitant with poison girl assassins in Indian folklore is the figure of the Icchadhari Naag, above whose head glows the crystalline organ Naagmani, which stands for forms of knowledge that haven't yet entered the body and hovers in the pure verbosity of raw theoretical flotation. Despite their ability to masquerade as human beings with superpowers, stories depict these legendary animals being hunted for the extraction of their crystal organ, through the administration of magical incantations (ritualistic theory as antivenom), accompanied by music and dance. The waxy layerings of ringing interiority introduced by Hands Receivers in later acts like Rasputinnitus located TwO in line with similar biochemical mithridatic precedents across Scythian Shamanism, imperial Russian court gossip, and Chanakya's *Arthashastra*. The results were ideologically addictive and fabulously trippy for dance floors.

Expanding into convenient distortions of a range of premodern ascetic practices such as *tantra* and *yoga* of India or Tarahumara Shamanism of Mexico, Hands Receivers constructed an elaborate plan to institutionalize his TwO experiments under the name Foundation Ƨ, in collaboration with fringe religious-political organizations in India that were

slowly gaining power. But he still needed a whole lot of plain propaganda and intellectual backing. It took almost a decade to find the right guys to partner up with. With a parallel base in Budapest, Leon Burp set up Hormel Python as the publishing wing that could legitimize Hands Receivers' forays into the domain of post-technological religious propagation in India. They began with a revival of old texts, annotated with examples from contemporary culture wars and odd political bottlenecks, and generally redesigned for the coffee-table consumer. Under construction was a mythology implicitly utilizing the mechanics of decay, pasted together from numerous pseudosciences, failed colonial programs, and shady racial theories. Somewhat like the Dianetics program, racial supremacist agendas came cloaked in a techno-utopian garb. The consistency of Spiritualist tradition in reterritorializing the post-technological self became an ideologically powerful point that helped Hands Receivers' claims to appear concrete. By the next decade, a steady stream of TwO extremophiles had formed—an assiduous bunch of heavy dancers immersed in incoherent soundscapes and noise addiction, who were by now thoroughly familiar with all aspects of *The Fourth Political Theory*, a recently published controversial book by the Russian thinker Aleksandr Dugin, the preparatory notes to which had constituted almost the entire last decade of content for most TwO sessions. With bold claims borrowed from the book to counter technosingular nihilism imposed by the West on societies such as India, China, and Russia, proposals to the Indian government for Foundation ℒ included these theory fragments morphed into consumable designs such as Dasein Pods, Multipolar Sonic Ideology Disseminators, and Subtle Body Synthesizer Clubs. However, as Duur Matter soon found out, far darker impulses hosted on dial-up connections had long preceded these proposals.

The latest probes encoded in Matter's investigative interfaces went rather deep into the obscure nodes of their malicious global network. Negative zones, containers, locales, holes, all sorts of concavities of the virtual. Through the electronic trash dump of the '90s, a human skeleton crawls out,

pointing at a previously unseen deep crevice in the garbage: the door to Kalki's messianic hell. As the garbage cluster creaks open, fluorescent light accompanied by synthwave music streams onto the military sensations of Abu Ghraib, Guantanamo, Khmer Rouge, Tiananmen, Kashmir, Gaza, Saydnaya, all somewhat out of context, endless scroll functions radiating Web 2.0 vibes. The environment is red and black, gray bricks patched about. Cheap graphics, like an old game. Pixel chops. Neon torture. Here we are, at the gross flipside of all civilization, with dissection videos, cancer tunnels, astrology projections, and insane fungal discotheques squirming under media exoskeletons. The amputated shadow will always pimp its wound. Welcome to the clock of deathboyferriswheel, celebrating holidays in the deepest canyons of the World Wide Web. An opisthosomatic secretion of bootleg biomass that radiated its own thoughts, it is less network and more trap, and the logged-in users, all prey. A hellish, heaving central tissue unit shoots out spinneret-limbs that double up for pages, each click on the mouse a spark of torture shooting through the flesh that formed well in advance of an ontology that could describe it. It swells like a clownish smile, infinite crustacean complexity all over, so colossal as to appear blurred, and so microscopic as to be just creeping itches. As Kalki 2.0 undergoes marination, his sword raised high on the flying horse moving at the speed of klansmessianic light across the dial-up cables, magnetic darkness flows backward from its drainpipe destiny, rising feet up from the ground, as the body of the sixth fragment of Kroni, called Kaliyan. Its devastating moody darkness is time itself made black. As a carbonaceous entity with corrosive qualities, Kaliyan stands for a stage of darkening that precedes messianic intervention in the Ayyavazhi mythological corpus. It is easily identified with the texture and feel of soot, with an outsized tongue, and a strong stench of decay and burnt matter. Etymologically sourced from the lexical root *kad* (suffer, hurt, startle, confuse), the name Kaliyan carries attributes of achromatism, gravity, and duration simultaneously, interlocking all of it into a space-time knot of ludic uncertainty. Born carrying an

upasthi (worship) bone, deceit is the entity's primary aspect, outlining the distinguishing feature of the temporal epoch that it represents. Origin stories go back to a primordial game of dice that divides all of time into four quadrants, with each throw delineating a cosmotemporal unit spanning thousands of years. But unlike clock time, each unit has varying qualitative aspects. In a progressively degenerative order of quality, the fourth quadrant of time—the very last one before the cycle repeats—is also the most diabolical, and assigned rightfully to Kaliyan. Embodying the idea of metaphysical contingency at large, the entity is also infamous for slyly escaping death by mobilizing time-travel functions across eonic spans and reappearing with added malice in altogether different cosmological aggregations. A thwarted immigration privilege grants it the unwarranted ability to inhabit the realm of gold, following which it begins to control a regional monarch through the goldwork present in his royal crown. Like a mad hatter on DIY mode, the king's nerves get rewired onto the crown from the brain. After prolonged exposure to this delirious metalloid influence, the miserable kingdom ends up crumbling in a wave of Naga snake attacks. A parallel version of Kaliyan's origin story shows it being born of a material remnant of the caustic snake venom *Kalakuta* (black mass or time puzzle) spewed out by the serpent Vasuki during the legendary Samudra Manthan (Churning of the Ocean). Snakes constantly slither in and out of this putrefactory treatise, probably intended to lubricate the fiendish loopiness of apocalyptic time.

However, in the prominently Hyperborean scheme extracted from the schizoid vibrations of Hands Receivers' musical constructs, Kaliyan also seems to have some secret affinity with the Scythian Griffin. Tied into the windy geography of the Dzungarian Gate and its subterranean stacks of *Protoceratops* bones, the Griffin has remained both a gold digger and protector of the yellow metal. The hybrid genetic inheritance of the Griffin fused with the inky mania of Kaliyan consolidates the synthetic fusion of mineral sensoria and mine-consciousness organized around the magnetic control over

gold, and therefore also of trade. This relationship is already evident in the fact that Kaliyan's power is essentially predicated on the impossibility of organizing the future as universally synchronizable time. Distinct from the simpler quadrants of mythical time that preceded it, under Kaliyan's schematics, future slides past the parallaxes of speculative projection, only latently sensed in the negative as a form of scarcity. The problem here being that the foggy darkness of the future would also manifest as a necessary precondition that dictates the present. The end-times retrobeamed as messianic vomit reflux. Unlike the eschatological essentialism of light as messianic resolution in premodern texts, the presence of Kaliyan on the online portals supported by Hands Receivers introduced a different dynamic. It aimed to corrupt the light brought about by the deployment of Reason, and in this manner relegate the forces of Enlightenment rationality itself into a messianic register by default. This new variation of chromatic defilement was a technosingular neuralloy darkness synchronized across the dense networks of technological capital, manifesting in cables under the sea, satellites around Earth, processed flesh packed and eaten all day, social media, streaming music, immigration bottlenecks, papers and paperworks, mines and roads, ships of cargo, sexbots of anonymities, all integrated into a unilateral technical grid stretched to the size of the universe. The Hyperborean imaginary had already been long invested in a reversed dialectics of light and darkness with its celebration of the midnight sun as a guiding beacon for spiritual revelation, and Kaliyan—already being the control room of time in the absence of light—became the preferred mascot for a technofetishistic reattunement of the lost arguments of Eurasianism in Hands Receivers' sonic cruises. Photon masquerade of such kind could even be a question of whether light is light at all, if it is all dark?

 In the days of glory, we all used to lounge together on beaches, with the Northern Lights illuminating coconuts, just another daily swagger of luminescence and nightness. Although no longer free gaseous fuzz, we were not fully solid either. Our jelly bodies bounced about, bumped into things,

merged and divided, all indeterminate in shape and with wanton infidelity to the protocols of matter. Limbs popped up often, and moodily disappeared, unreliable in speed and consistency. Us Obscure Blobjects of Desire, we became one through splitting.

> We were many before we were one
> making a crowd in the presence of none
> We danced to the groovy scales of Monk Jell-O-Nious:
> "It's always night, or we wouldn't need light"
> Never a benign bore, we Hyper-Bore

But like Tlönian *hrönir*, the constant repetition of our flesh and jelly "pudding-bag" projections (name attributed to H. P. Blavatsky) had a strange solidifying effect. We became permanent. Earth was probably no longer in vertical alignment with the sun. There was a tilt. Our tropics were freezing, while we walked heavy to the equator, operatically swaying to the tunes of our newfound body lumps.

Progressive solidification of organic-intellectual material as live by-product of a climate exodus is a central call to adventure in the Hyperborean narrative. Budding, parthenogenesis, and dysgenic trajectories were dwelled upon in great detail, especially in the writings of Helena Petrovna Blavatsky, Charles W. Leadbeater, and Edward Powell. A root race that divided like amoeba without the intervention of sex became a prehistory to the devolved and solidified contemporary human. The timescales under consideration were expansive; instances of pterodactlys or megalodons casually cruising past human settlements weren't rare, with an elaborate series of diagrammatic charts explaining natural history overlaps with the spiritual geography of Theosophy. Degeneration advanced as the human race drifted farther from the glow of the midnight sun that had now become coated with the wet sheen of perennial snow, Earth flitting like a party lamp with the black light beaming through the holes in the poles. The solar oligopoly of the Mediterranean Garden of Eden needed some counterbalancing. Hands Receivers sees the

tunnels within the hollow Earth turn into a soft chugging tissue, an intestinal canal coated with contaminated mucous-code, an instant biohazard remolding all organic matter into technological Gestell-Clay, bursting open with Silicon Valley nanowormbots screeching cartoon giggles. Flares of the midnight sun reflect off the sunglasses of the Griffin eating it like jelly fruit. The pudding-bags are back in town!! smoking *sheesha* with Blavatsky in Constantinople, she on her way to becoming a demigod plaster cast in Adyar. Griffin eggs are stone-tough, discovered the Theosophists, playing hardboiled billiards under the towering banyan tree there. It took a while after her arrival in Madras for Annie Besant to realize that the UFOs seen above the Cooum river were in reality Griffin nests, piloted by tiny lion-faced bird cubs. What Indian nationalism owes to UFOs was a matter of particular interest for Hands Receivers, it being also the main conceptual catalyst to consider including Dizazel Babyloneon's corpus of texts in Foundation Ϩ's plans.

The mangled body of a child is embedded in the brand identity of the Angel of History. In his memoirs, dripping with insult and mockery, the archetypal otaku likens it to the slow-cooking of a tortured reptilian god in rabid spirit oil. History burns as spirit, soot dark with sticky fumes coating all over. Like crusty rodent fur. Tsutomu Miyazaki, later dubbed the "Otaku Murderer" due to his alleged fascination for anime and manga, had attributed all his murderous instincts to Rat-Man, a parallel entity that resided inside him, perhaps somewhere unawares among his internal organs. This entity was persuasive enough to have Miyazaki inflict rape, necrophilia, and cannibalism on several children in Tokyo, in 1988. All of a sudden the game turned on its head. The reptilian god being cooked at the moment revealed itself an invulnerable Atlantean beast, the arch-enemy.

Snake out to eat Rat
behold my food chain! clamping heavy

Chased and smoked out in these dingy sewer streets, Rat was losing it. The libertarian hunter beast would, however, later turn out to have strange, asymmetrical collusions with Rat.

In fact, its heavy gaze was what gave shape to Rat within, Rat turned stone, peeking out, tearing through Miyazaki's pants.

 Rock penis looping magnetic tape
 dynamite cumtrolling
 anime unable to move on TV, all sticky now.

All the while the spirit burned carbon dark, smoked out of the uncanny valleys of silicon. Otaku culture in Japan visibly migrated off the magnetic eroticism of VHS tape into the post-pornographic parthenogenesis of the World Wide Web in the early '90s. Virulent hormones online dominoed over the decade into a series of forums with real and virtual potentials for material damage and ultraviolence within users and against whimsically targeted public spaces or media personalities. The feeling largely was that virtuality ate into the real world, confusing the order of things. "Bad data" fought "good data." There were ray guns, laser weapons, plasma generators, and earthquake machines, bright flashes, punk hair, and cartoon wounds. The scientist Hidetoshi Takahashi, one of the masterminds behind the Aum Shinrikyo sarin gas attacks in the Tokyo subway in 1995, explained the logic of such a battlefield through an elaborate jamming of ideas around mind control, subliminal imagery, and advertising strategies corrupting a world drugged through virtual media. "Though there may be some who do not believe in Harumagedon, it is not a matter of belief in the usual sense. The notion of the 'end' was inputted into our generation as a general sense of things. ... Our favorite anime such as *The Space Battleship Yamato*, *Nausicaä of the Valley of the Wind*, and *Akira* all dealt with the theme of the state of the world after cataclysmic destruction," clarified the scientist in an interview after the attack. The way to undo "bad mind control" was to produce counter-content with "good mind control." Aum Shinrikyo, engineered as a monstrous hybrid of Indian Buddhism, Tibetan Buddhism, Hinduism, and Christian Millennialism, under the guidance of its founder Shoko Asahara, conceptualized a labyrinthine hive of delete-and-overwrite command protocols aimed at inputting "good data" in place of the devious techno-influentiality of school curriculums and media houses. Anime

and otaku culture held a double blade in the Aum universe; although denounced as evil propogandist content tranquilizing youngsters into conformist submission across astral and causal worlds, it was also taken as a prophetic medium with the potential to instigate divine revolution. To this end, Asahara began to create some manga and anime content of his own, as a method to counter the "bad data" of the brainwashing "School." As the group advanced further in its program, fears of Aum's own commune being attacked with poison gas by unknown assailants magnified. Was it the Japanese state, subliminally sexual potato chips in advertisements, Soka Gakkai, or the US military? What might explain that ghastly stench in Kamikuishiki, interrupting those yoga breathing sessions? Spaceship Mahayana spews fuel, ready to launch with Asahara as captain. Poisoned lungs float into space like helium balloons, squeezing out through the mouths of virtual-reality soldiers. The war is intense, with the village under toxic gas attack for years, everyone's health deteriorating, all and everything in collapse. Harumagedon is here. With the costly glimmer of an ad, Cosmos Cleaner equipment arrives from another planet, to cleanse the world. "When we were traveling by car once, I sang the theme song of *The Space Battleship Yamato* with the Master (Asahara). The Master said, 'Yamato was a ship carrying the last hope for the earth. It's just like us, isn't it?'" By the time of the Tokyo subway attacks, several pieces of Cosmos Cleaner equipment—air-purifier machines named after *The Space Battleship Yamato*—were found in the Aum facilities. Many of the female staff of the commune also had styled their hair to look like Stasha, queen of the planet offering to help the Earth in *Yamato*.

Quintessential tropes of scheming vermin having already manifested in Miyazaki's case as the evil Rat-Man, as if "inputted" retroactively to eventualize the imminent projections of Aum Shinrikyo's antisemitism, served also to directly fertilize their hatred for otakus. The shadowy Rat in action would suggest that rodentine Jewish powers had always been afoot in Tokyo, crawling through the gutters, which were also the mind of teenagers, the *guro*-sewers bursting out of

Neo Tokyo libido-architecture, the terrifying large soft-toy Rat of Harumagedon realized in bootleg VHS tapes of astral *Akira*, now playing in the neon visions of Aum Shinrikyo meditation halls. The Rat was the Corporation itself, the sheer substance of the high Wicked City towers rising out of the ashes of nuclear destruction, or the seductive femme fatale skin turning into cold spider spit. As far as Jewish conspiracy theories went, Miyazaki might as well have been an "organ of a foreign will," an instrument of hypnotic crime puppet-controlled by corporate entities, legal-fiction webs disseminated by trade-borne wandering pests involved in swampy trade. Trade of foul bodies, soul bodies, ghoul bodies, trade of will itself! Liquid soul leaking from gold-tooth cavities. Who else is the "actual culprit" but the Corporation? The headquarters with no head, or head in quarters ain't it, fragmented in blocks and blocks and powder points, scattered, driven away like dust, the pulverulent aggregate of nothing rrreallly :) It was like spiders sliding down those quiet Tokyo residences at nighttime, having people for dinner midway through their dreams, just their hair left behind as clumps of damp arachnid spittle. "Inputting" was swarm warfare. Anime, the School, the Advertisements, the secret messages hidden in the action lines of cheap bullet-train manga all the media druggery the popsicle fuckery the schoolgirl stereogram skirts the giggling bondage fairies, all particulate matter aggregating like neurotic dust bunnies out chasing those kids, instantly sucked out by Cosmos Cleaners lollolololoolll ... The Corporation. The School. The Cathedral. All fictions: "*legal fabrications akin to literature.*" In this case, like pulp literature, chewed like gum, crushed to paste and ingested deep deep in the system. Becoming-corporation, becoming-bureaucracy. "The aggregate person is not a dead conceptual thing that would require representation by other persons, it is a *living organism that wills and acts as such.*" In the same manner that organs of the human body constitute a self-aware totality, the plurality of different corporate members merged into a distinct unity of a cohesive aggregate person. The "personality of the corporation" was "not an externally feigned illusion but an

inner quality of its essence." With Aum Shinrikyo, the Age of Fiction was declared conclusively over. Shoko Asahara's greatest desire was "to create a robot empire someday." But his powerful machines ended up scavengers, eventually foraging crumbs of Grand Narratives, slowly hunted to extinction by giant cursors. Cursors being *mouse-controlled* entities simply reinforced the schematics of remote vermin influence. There were no arboreal flows anymore. Roots reigned in Khthon. "If the Red Army and the people who sensed themselves to be of that same period represent the demise (or limits) of the idealistic age, Aum Shinrikyo represents the demise (or limits) of the fictional age." As Ōsawa Masachi explicated in *The End of the Fictional Age*, they differ only in that the former believed in communism, a widely recognized narrative, while the latter believed in a narrative that was still having difficulty winning broad recognition. Fictions could no longer collect into cohesive ideologies, personalities, or anthropomorphic figures. Bits scattered about in Hyperflat 0 - 1 - 0 - 1 GUI mesmerism, as the Y2K anticlimax imploded in the dance of Otaku as the Angel of History, flitting its forked cursor-tongue out in magnanimous 8-bit pleasure, one tip poised toward the past and the other toward the future.

The black soot remained, undead fiction particles collecting sticky. By the early 2000s, as the Hyperflatlands squirmed with dank memetic undergrowth of Web 2.0 infrastructures, reptilian fables proliferated rapidly. Snake-like, worm-like, tentacular, hole-y entities born of fictions outliving their dead age, grafted in 3D meat. Riffing on a hipster version of Pascal's Wager, a malicious, all-powerful artificial superintelligence program was spoken of that would torture to eternity any human who would refuse or be indifferent to the cause of bringing it into existence. All in the future. Of course, this punishment would be meted out to digitally recreated simulations of current humans, since the Superintelligence would hypothetically be able to reproduce all the requisite data needed for recreating human minds with their subjective memories, nicely wrapped in their erstwhile bounded body. The thought experiment, although philozombie noir at one

level, wasn't taken lightly in the host forum LessWrong, back in 2010. Like the Necronomicon, simply knowing about such a computationally advanced entity was itself enough to become its target, retroactively. The user Roko was trolled heavily for spreading this perfect information hazard, which soon earned the name of the mythical reptile that turns to stone whoever meets its gaze—the Basilisk. Part snake, part rooster in traditional representations, the Basilisk was also known as the Serpent King, mainly due to its anatomy boasting a crown-shaped crest on its head. Roko's Basilisk does not fit neatly the usual structure of prophetic time or autosuggestion. The present itself is preconditioned by a future built on fictions deployed for the same express purpose. This *Hyperstitional* function ("equipoised between fiction and technology" à la CCRU meat puppetry) of entangled cause-and-effect became the ingenious evolutionary tactic emerging out of the wastelands of rotting Hyperflatness (*chōheimenteki*). Notwithstanding its precedents in occultural interventions such as the Crowleyan Thelemic Will, Hyperstition advanced a political direction for fictional quantities within the context of cyberculture at large. The Trishankuesque suspension between the spatiality of hypertext and the affective futurity of superstition became a necessary weaponization of liminality and capitalist time regulation, programmed to bring down the normie Cathedral fortifications. Incidentally, the christening of the normie media machine as "the Cathedral" created a lot of stray byways in emergent masturbatory counter-media networks (artificial *incel-ligence*), deep affinities spawned by a young white male population swooning under the demands of first-person shooter games and silicone pornography. Notably, a historically divergent position by the scholar Jochen Hörisch, for example, identifies the body of any corporation as principally female, due to its alleged correspondence to male desire. Apart from neglecting the homosocial sphere of desire directed at male bodies altogether, Hörisch also overruns the historical associations from the Middle Ages of the church with the female body and the state with the male body. The Cathedral nomenclature retained such characteristics as slurred

pejoratives, cucked and redpilled for the lulz. The Cathedral bred beta males, while real males broke free with the right chromatic choice of prescriptive ingestants. Morpheus smiled. Nervous, whiny, and moralistic, the Cathedral was visibly histrionic-neurotic in a weaker sex way, so easily normie that only the Corporation's big CEO energy could dickfix. Governments are for sissies. Comic laughter. Bring on the Mars.

CREATURE
SYNTAX

A rather prominent network of online fake-news handles in India found its servers badly hacked one morning. The lazily doctored images of temple destruction, posted on various social media platforms, had now been contaminated by trending meme animals. In some sense the incident was rather obscure, far away from Goa, in some of the smaller towns in central India, and Duur Matter had stumbled upon it quite by chance. As far as the abduction investigation went, he was at the stray ends of a long and bizarre trail of evidences, McGuffins, and utter weird shit. Time zones outside historical measurements whizzed past as he dug through the entanglements in the case. Detours along the

quasi-religious interests of Foundation Ƨ pointed to scattered political entities, which, although operating away from the mainstream electoral practices of the country, were more like aggressive appendages to the main parties in their respective districts or states. Most were organized around clear hierarchies of caste and land ownership. Power interests within their ambit were rarely articulated along "religious" lines in the broad anglicized sense, and narrower divisions within regional communities mattered more. Foundation Ƨ had been in conversation with the leaders of many such outfits across the country; there had been meetings, marketing pitches, dubious land deals, and publishing contracts heavy on bribery and missionary zeal. The fake-news network had originated somewhere in that clutter and seemed to have as its mastermind a dubious character with a quasi-religious aura about him. Apart from having informal political control over several districts in central India, he was also known for being the managing head of multiple *akharas* across the region. *Akharas* are old institutions with both monastic and martial training to a degree; descending loosely from Saiva warrior asceticism, their military lineage has remained symbolically continuous since at least a thousand years. Contiguous with their social organization is also a culture of servitude, where hundreds of men are inculcated from a very young age to be completely submissive in their incorporation into the *akhara*, headed by a master or commander figure. The news network appeared to somewhat mimic this archaic sense of authority, as was visible in its rickety offices located in the poor back alleys of mid-sized towns. Underpaid groups of young men with basic image-editing skills worked on a bunch of dusty desktop computers, tediously creating images of the destruction of nonexistent temples and idols, mostly based on stone architecture. The structures allegedly subject to damage were deliberate composites, put together from the internet and history textbooks; a broken limb of some deity, a sad granite column, an abandoned bust, all newly born as ruins. The strategy behind was somewhat simplistically contrarian, in that the blame for such made-up sacrilege on idols or

temples would blatantly be thrown at rival communities or religious groups, even foreign-national conspiracies at times. The political outfits negotiated their regional leverage regularly with such tactics peddled locally on a daily basis, keeping communal tensions simmering on low-key heat. Within the virtual world, however, the geographic range of interest was vast. Anything pseudo-morphically resembling the subcontinent's architectural or sculptural heritage would pass for possible fakery: Hindu, Buddhist, and Jain temples, and their numerous associated regional variations from Afghanistan to Indonesia, were mobilized in service of an elaborate and lumbering propaganda apparatus. Quicker, less seasoned forgeries even took from Orientalized open-world video game screenshots. In as much as all pattern recognition programs are disguised segregation tools, cultural fantasies of Akhand Bharat—an undivided Indian subcontinent—were unconsciously getting reverse-engineered from the algorithmic ruins of architectural data, seemingly by accident, but more likely through inherent bias.

The network as a whole, however, was shocked by the virulence and precision of the hackers' attack. Particular architectural or sculptural elements that were regularly forged to make up the fake imagery—such as figurine parts, pillar engravings, and temple facades—had been retraced in great detail to their original internet sources, tagged, and replaced with mildly humanoid animals. Cats, fish, crabs, capybaras, caracals, hippos, crocodiles, frogs, cockroaches, and many other creatures of decidedly suspicious lineage constituted this collection. A detailed taxonomic system might even have been in place, with all sorts of seemingly obtuse metadata exposed, such as the original download locations of the plagiarized imagery, the trending memes around the region of origin of the image, and the animals popular on the web there, as well as how they compared with the actual zoological profile of the region. All of these, again, tied to the names of particular historical kingdoms of India that were used as pseudo-propaganda material by the fake-news network. Sometimes interlocking trends and search results caused

algorithms to throw up fusion animals. These were included as bonus imagery, sent exclusively to the personal mobile devices of the regional politicians who funded the network. Pixelated, corrupt, and contaminated in all capacities, this animal revenge brought with it a nasty foundational affront to the toxic statements of the propaganda network.

Although limited at present in user range and political effect, the network threw up for Matter's perusal some wicked crumbs of documents related to temple destruction and iconoclasm on the subcontinent from way back in the late eighteenth century. Prior to the survey records of British India and German Indologists, these inordinately complicated cases were documented in the personal archives of the descendants of military families, particularly in the region bordering old Bundelkhand and present Rajasthan. The region was an important geocultural frontier between the Gangetic north and the Deccani south of India, prominently known as the homeland of the Bundela Rajputs, an extended clan of warrior chieftains who had stabilized there by the sixteenth century, somewhat parallel to the Mughal reign of Akbar in Agra farther north. But the military families in this case belonged to a different lineage, particularly those known for their stringent ascetic stance. To be a soldiering ascetic (*yogi/jogi/ioghee*) was to have the sword as one's mainstay, which, unlike their descendant versions today, gave the practice a corporate sensibility, not aligned to any of the normative caste identities of the time, which were based on biological loyalty. This leveraged for them a fluid and ambiguous field of power that transcended traditional meters of status and demanded instead direct skills like military acuity and subcontinental mobility. Depending on the highest bidder, warrior ascetics of the region would sell their military services impartially to Hindu or Muslim kings and, later, to British or Dutch troops. Despite their vicious fury and manic aggression in close combat, complete with sharp head-slicing metal disks (*chakras*), slippery oiled bodies on cavalry, and swords of rigorous metallurgic make, the *yogis*' extralegal status was primarily a result of their notorious supernatural abilities.

In this sense, their ambiguous affinities to institutionalized religion might have meant a wholly different orientation toward the understanding of religious practice, given that their sole aim was to war against death itself, and master immortality. Nothing less would suffice as a legitimate goal. Metempsychosis (a.k.a. nest-to-nest intermigration), flying through air with the aid of specialized quicksilver, targeted reincarnation, and superhuman sexual prowess were just the best known among a swarm of occult powers commonly associated with these ash-smeared wanderers. Two stories even describe a complete replacement of the soul of the Mughal emperor Akbar while alive by some adept *yogis*, one through direct soul swap and the other through strategic reincarnation. Going by these archival examples at hand, Matter thought, fake news was surely a lot more of a crafty affair back in the day, flavored by a rather portentous sense of metaphysical conjecturality.

The landscape around the entire province was mostly semiarid, rugged terrain, with thickets of forested land and giant fortresses abruptly erupting on hillocks. Mughal expansion in the larger region had imbibed in the local rulers a rather pacifist disposition over the generations. As a consequence, the older Hindu temples around had only limited protection within the legal king's jurisdiction, and therefore relied heavily on the support of the ascetic warriors to maintain and keep guard against invasions. Numerous sites lay scattered across the forests and hills, probably built during the more powerful earlier empires, even as far back as the ninth century. Half a millennium of neglect had made legend this almost inaccessible religious architecture, gradually blending in with the literature and poetry of the time, which rendered stories of regional political loss in garbs of marvelous fantasy. Yet even by the standards of their baroque repertoire, the story of the effaced temple complex still retains a singularly disquieting status. At its most basic, it was hard to even describe the material fact that temple sculptures were losing detail. As such, the complex was known to have been there forever, spread across the

forest and caves, shrines, and some isolated freestanding worship halls, always overgrown, always abandoned, taken as perpetual memory rather than physical space, often visited by monkeys, bats, rats, and leopards, with occasional python sightings considered not unusual. Apparently, the rocks had begun to decay. Some bent time, some accelerated patches of fossilization or a smoothening of edges, with granite details going foggy. The summer heat was already tough. Air was stone and stone was fog. It was impossible to breathe. The sculptures were fading in parts. Delicately carved *mudras*, *yogic* postures, sexual acts, *sabha* scenes, all the standard Hindu temple fare, drowning in the rock itself. It went on for days, maybe months, unfolding in hypnotic slowness, as if some ethereal summer music were melting stone by stone, enticing Earth's core to advance upon the surface, to reverse some unknown fundamental sin. Shore temples had been seen to become eroded over hundreds of years, but the sea was so far away it could pass for traveler's tales in these parts. The afternoon winds had begun to eat rock. But even the lucidity of the speculations wasn't prepared for what followed: the appearance of the animals.

Trickling slowly into visibility, they gazed discreetly out of the dusty vegetation. Faces holding gazes, dust and wetness shaping out of abstract green and brown. Biodiversity being quite rich around these forested parts, locals had always had their way around animal presence; wild and domesticated creatures were common in paintings, myth, and song. But the faces! The animals looked all right, except their faces seemed different—or, rather, now they actually *had* faces. Granite human faces, postured like the gods, carved like in the caves. They appeared somewhat pasted onto the animal heads, but fused intricately with fur and skin, firmly integrated with their bone structure. In parts, the combination was unclear, sometimes fingers or eyes, still in granite, blended with animal bodies in all their grace, face contours often in formation. The sheer physics lacked credulity, with the wondrous dexterity of animal movement continuing with ease, in spite of the evidently heavy alloy of bone, flesh, and stone. Monkeys,

snakes, leopards, birds, frogs, lizards, and even insects were seen, mixed with incomplete facial attributes of temple figures. With tales of *yogic* wizardry already rampant, the villagers' reports of hearing speech-like garble combined with animal whimpers were absorbed rather quickly into the social milieu. Unable to step out of their homes for fear of being hunted by these scary chimeras, the entire population was soon mired in some deep and novel horror.

Duur Matter noted, however, that the mood of the scenario stuck out rather sore from the regular miracle propaganda of the warrior ascetics that had been in circulation in the 1700s. Still, the notion that the faces were *stolen* by the animals was striking enough to spawn a trail of connections in his mind. The overbearing sentiment in the kingdom was that an act of sacrilege was ongoing, that the temples were *de-faced*, and therefore measures had to be taken to *re-face* them. This point struck Matter as a potential strand leading up to the social media hackers, who had replaced all the emoji-infested hate speech of the fake-news network with a philosophical thread on the making and unmaking of faces. The next few sections of the Bundelkhand archives overflowed with lengthy descriptions of cryptic exorcisms and dark rituals. After days of ineffective ritualistic trials, the rulers and the ascetics, all remained confused. It seemed some ancient model of cosmological exchange was getting scrambled, with the invisible contract that bound animals and humans to the divine marketplace now degenerating into corrupt chaos. In desperation, a royal hunt was ordered to kill all the mutated animals, the plan being to retrieve the stolen granite faces from their carcasses and sculpt them back onto the temples. But what about the million insects and migratory birds? The termites, the fish, the earthworms, the crushed wasps that kept smiling back with their tiny granite faces stuck to the clay wall dripping dead insect tissue Jain monks their masks covering further unseen faces a billion bacteria giggling in chorus. The horror only multiplied. The hunted animals, after skinning and cleaning, revealed malformed bone-and-stone endoskeletons. No known tools or weapons could cut through

the mad thickness of those formations well enough to extract any legible sculptural sections that might combine back into the temple granite. Meanwhile, the temples themselves had by now almost entirely disappeared; all that remained were large abstract masses of rock scattered around, with no sign of having ever had any human intervention on them. Huge patches of forests had been cut down or burned as part of the hunt. The landscape at large was altered. The artisans tasked with the potential reconstruction of the lost temple sculptures from animal bones were overwhelmed by the oddity at hand, and could no longer suspend their fatigued disbelief. News spread that exposure to the animal bones itself could cause madness, not just for the artisans but for the entire population around. At a time of almost constant political instability, this was enough cause for panic for the kings. They ordered the entire rotting bestiary buried before the onset of the monsoon season, after making sure, however, that at least all the larger, more visible hybrid creatures had been definitively eliminated.

Shrouded in secrecy and flavored with supernatural intrigue, this narrative of the animal-temple swap seemed to Matter a suspiciously convenient cover-up for something, though it was hard to tell what that might have been. Possibly the abrupt development of a trade of temple relics and idols, especially in light of the new class of European travelers and armies getting involved in the region by the late eighteeenth century. It was even likely that the *akharas* played mediators of such exchanges, considering their famed shrewdness in political alliances and communal independence. But there was no conclusive inference possible in general. In the recent server hack incident as well, the clues embedded within the conspiratorial strands were labyrinthine, particularly the entanglement with this remote, old-time curiosity of a text. The thematic of mimesis, for example, hyperlinked rather far, as the hack images seemed to have deliberately staged a close resemblance to popular neural network programs trained on animal data sets. The attackers had been imitating machine styles.

SONIC SPLATTERATURE LP #0
BONE RESISTANCE VECTOR

In the extremely likely event of a machinic singularity in the not-so-far future, it is of paramount importance that humans do not become prey to a machine invasion and be made meat to feed their batteries. The only notable precedent warning of an upheaval so major, at the level of the species, was marked by the delicate sound of crackling bone, when humans themselves realized that in order to stop being prey, one has to imitate the predator. The scene must have resembled a totemic field, traversed by tall intersecting shadows, as towering bipeds walked the earth. A section in *Sathapatha Brahmana* stages this as a primeval time when humans and animals both stood upright. The entire solar economy might have looked different by design, with giraffes, kangaroos, tigers, elephants, crocodiles, cats, and every other animal, including humans, all aligned to an originary energetic axis that is now long forgotten. Even photosynthetic flows obeyed a different geometry, with trees shaped along imperceptibly different solar channels. Contrary to the familiar Darwinian version, there was never a time when humans ascended upright from a crouching four-legged posture. It was the animals that were made to bend down, to cower under fear. But fear of what? The greatest technical tool that mastered the nuances of cosmic exchange: the sacrificial post. An octagonal post, maybe visible as just a wooden stump sticking out of the grass, but the grandest of trades between the living, the dead, and the divine were mastered on it. Prior to this intervention, the humans were slave to the animal, hunted at whim, with no recourse to proportionately effective defense mechanisms such as fangs, skin, or poison; not even speed. The view from the pits of the food chain was, in all its banality, a steady nightmare of predatory hostility. But now, struck in terror by this new exosomatic claw of the human jutting out of the earth, the animals bent down in mass spinal compromise. A dull shudder of calcified tissue leaked across the biosphere, whirling into the new order under formation. Spine bent by

spine, as it became known, because the sacrificial pole was also Indra's thunderbolt, crafted from the spine of the sage Dadhichi: "Then the gods noticed that thunderbolt, i.e., that sacrificial post; they put it in the ground and, for fear of it, the animals became crooked and four-legged, and so they became food, as today they are food, because they gave in: this is why they immolate the animal at the post, and never without a post." Fear of a technological singularity retains the memory of this radical and unprecedented evolutionary rupture that changed the order of consumption, initiated by the distended act of mimesis and followed by the technical expansion into the sacrificial post. All concerns around machines attempting to imitate humans continue to be centrifugally organized around this primal change of bodily axis, tied to animality, with the uncanny valley being simply a topological anticipation of this mimetic compulsion.

The region, plotted at a stretch from the almost wholly unreliable records, was still quite a distance from any urban center in central India. After a quick teleportation session, Duur Matter found himself, once again overdressed, in the middle of a decrepit road, which, he later learned, was in all comic seriousness called a highway. A modest car would barely fit it, tires often seen spilling past the sides, raising minor clouds of dust. By all means, these inland regions seemed to have lost more than just political power since the time of those old stories. Empires with no access to sea would've anyway had a hard time anticipating the advance of maritime financialization and its impending reconfiguration of the world order. Representative of this aquatic drift is the biographical curve of Prince Dakkar, popular by the name of Captain Nemo, who was a nineteenth-century descendant of the Hindu kings of Bundelkhand as well as Tipu Sultan of Mysore. Fatigued by the accumulation of political failures in his lineage, he had invested in new technologies to build his submarine *Nautilus*, which cruised deep seas, rejecting all the trappings of surface civilization and the law of imperial tyranny linking up the world. If Nemo's anti-imperialism and

savior complex were any hint, even the marginal possibility that the underwater remains of *Nautilus*—now speculated to have been taken over by some covert maritime entities invested in disruptive krakenpolitik—were involved in the writer's abduction in Goa could not be entirely ruled out. In retrospect, it indeed looked as if the mystery of the temple sculptures was a dark, funerary forewarning of such grand transformations of civilizational scale. Now crusted with layers of old time, the entire geography felt sunk, defeated, and without will. A long and tedious walk led Matter past railway tracks, near-abandoned shanty towns with mostly just tea and beedi shops, and farmlands all famished in appearance into the far out deserted plains with the fabled ruins, still reminiscent of the archival descriptions. The expanse was considerable, yet they were ruins of nothing—it was just boulders all over, overgrown with forests in parts and bare elsewhere. The disappearance of human craft on the stones was absolute and perfect. But for Matter, this was exactly what constituted their monumentality, their sheer invisibility, much like the Egyptian statues, whose gaze, regardless of their physical height, has always been observed to pass above one's head. The manner in which one walks surely has something to do with the way a monument makes itself appear, for it was only through recurrent walks that Robert Musil observed the remarkable act of negation involved in the appearance of the statues, their extraordinary invisibility, something that paradoxically imbibes in them the power for an exceptional degree of animation. "There is nothing in the world as invisible as monuments. Doubtless they have been erected to be seen—even to attract attention; yet at the same time something has impregnated them against attention." Does negation itself accelerate or arrive in waves, turning abstract sites into monuments in discreet collaborations with technologies of arrival such as airplanes, ships, cars, or spaceships? Or are monuments only perceived necessarily through a lapse of attention—or maybe of "consciousness, if not of being," as observed by Jalal Toufic—citing the case of Jonathan Harker's surprise, upon abruptly arriving

at the Count's castle on horse-wagon: "I must have been asleep, for certainly if I had been fully awake I must have noticed the approach of such a remarkable place." By a similar paradox of negation, the temple site in its entirety had now become a pure zone of nonattention, centuries after unfolding its own monumentality by mediating a sequence of weird exchanges between humans and animals that, step by step, had rendered the entire temple complex invisible. The utterly novel sacredness of the site suddenly descended on Matter, standing rather lost amid the sordid overgrowth, dust, bat droppings, and faint smell of industrial waste. Right here was the secret, animated as if undead, made to act with extraneous agency. The same secret spoken of by Elias Canetti, unveiled like a flash of lightning. There is surely something about the secret, the flame of negative labor, that is inseparably connected to the twilight shift over from animality, the glorious pink and purple psychedelia of the *un-visible*. The zebra herd Rorschach dissolving savanna grass. The secret prowls in darkness. The secret is itself darkness. The animal in anticipation, the immeasurable patience of a predator awaiting prey, in darkness. The secret is a ticking armor around the body, an exoskeleton of time drooping melancholic like the skin clocks of Dalí. And then the explosion of action, a blinding flash tearing at the secret, the prey struck dead, dying, in pain. Light diminishes again inside the alimentary canal, as the flesh is ingested, and bone and bacteria mix, all back to black, back in secret. The darkness of the intestines takes over. That faces have so much to do with the mechanics of darkness, with the very operations constitutive of marring them from sight, i.e., of masking itself, came about as a minor revelation to Matter. Harker, too, realizes upon encountering the Count that the armor of darkness is an inseparable part of the monumentality of his pale face, masking what would otherwise afford no image or reflection (the Count being a vampire), a stark incongruence within quotidian solar economics. The alternation between the flash of revelation and the absolute murkiness of invisible negation characterizes this puzzle of the face, that monumental locus of sacrifice.

SONIC SPLATTERATURE LP #1
THE FACEHUGGER VECTOR: A BUREAUCRACY OF WOUNDS

Inasmuch as an aversion to surfaces did characterize the secret in its more devious forms, the theory of *Zombie Nautilus* (which is how Matter had begun to refer to it) began to seem more and more plausible. For the secret was always sunken, constituted of piercing interiority, while simultaneously also in orgiastic union with the exorbitant wastefulness of the sun. This double potentiality (forked tongue of dancing Otaku) made its menacing presence in Western history at large as the *south*. The salty Mediterranean South of biblical revelations that had the Hyperborean North up in arms, those jelly bellies rolling snowballs ... In other words, the rather predictably primal European divide, which later also came to be seen as a dividing axis of wealth, always climbing relentlessly "upward" to the North from the sultry pleasures of the South. The glorious South that is body and disease, the luxuriant tropics, the Rorschach savanna, the grotesque Venetian sculptures all of a sudden too visible in the sun, Meursault's hallucinatory killer sun, the overgrown genital-beard-Freud's face caked in cocaine! The Cockaigne South, which is also the deep, is always host to the secret, those zones where whispered complicities between void-objects unfold, ripping through the fidelity of surfaces, the swampy green fellating the sun's excess, as in the unbreathable equatorial thickness birthing Conrad's slide into the ancestral jungle, the unfathomable uselessness of violence, so casual so bright so exuberant, always scorched, always too much too much too much ... In Nemo's case, even justice lies incubating in the deep, within the secret, while thalassocratic imperialism wreaks havoc up above, on the surface seas.

Far in the more incomprehensible light-year depths outside Earth, the stomach-piercing screams of the *Nostromo* (*Alien*) that no one hears (*In space no one can hear you scream*) coalesces these planes of possibility within the incubatory darkness of the body and the secret's libidinous eruption, into the point of the fatal tearing of abdominal skin. Truth is

afforded by the surface only at the instance of puncture, the lightning flash, past the wild pre-intestinal temporality of infinite anticipation … It is due to this covert pact with the labor of the negative that the reproductive equation of the secret is initiated through the aggressive possession of the face of its human host, who temporarily wears its own predator like a mask. Defacement of the host, or forced masking of the host, becomes in this case an apex predatory gesture par excellence. The Xenomorph's invasion is doubly weird because of this total gesture of concealment, as if the secret already exists *within* the host. Concealment is the gesture of wrapping in negation what everyone has always known. The barbaric xeno-secret is in fact knocking on the impenetrable fortress gates from the inside, the secret made so unpalatably strange *precisely because it has always been there*. The Xenomorph is to humans what the sacrificial post is to the defeated animals, the body-technic that overcomes the evolutionary trajectory of the human face, with the acid-dripping phallic mouth of the alien poised in fanged mockery of outdated divine exchanges.

The secret in the valleys of silicon is carbon, while the brightness is in plasma, the LEDs, the emojis rollicking on screens, the surface glowing while the exuberance of the deep is traded in the deep web and the dark net, the search engines blooming data exhaust, the southern fumes of the internet regurgitated as surface capital, the surveillance nodes, the sustainable terraforming vanity makeup, the dark side of the sunny-side-up, the smiling cosmocosmetics of satellite pretties dancing the orbits, the TV screens shaking with interstellar disco static, ADHD(4K?) pandemic spinning the little globe still on wheel-and-piston sexual parody mode the lolololollllllization of the sun in hilarious retrograde … The camera-flash-like anus of the ape swinging past the screaming children at the zoo, so blazingly described by Georges Bataille, might as well have been a smiling-face emoji, both eyes converging in comic solar fornication. At the evolutionary apex for Bataille, rewriting both Darwin and Freud, is the strange organ that he calls the "pineal eye,"

located at the crown of the head, ecstatically linked to the sun in all its excess, a "solar anus" that harks back to the prehistory of the face as a sacrificial site. The organ is the result of a synaesthetic crossover from animals to humans, when the animal olfactory sense transformed into a visionary highway aligned to the sun, upon assumption of the upright human posture. The familiarity of the excess, the secretive pact of its invisibility, the negative labor expended in this mad mad economy of always the most known being the most invisible of all things, this is where the face brings forth the secret that is always public, but also perennially masked. The face is the secretly familiar, because the face is also genitalia, the masked secret, the public secret, only retained by either being never mentioned or being continuously spoken of, like sex or polite talk. Any rupture of the secret, as in the lightning strike of the hunt, contrary to destroying the face, *re-faces* the face. The public secret resides at precisely this Penrosian Eden, where laceration, faciality, and the sacred intertwine *accursed*. "As in the way the English language brings together as montage the face and sacrilege under the rubric defacement," remarks Taussig, while noting that "we should also be aware of cuts in language, strange accidents and contingencies" in this regard, since "it is the cut that makes the energy of the system visible," recalling Elsaesser's thesis on the power of Dada cinema. Man the fallen animal, rolls in panic down the descending steps that perpetually ascend ...

> a careful ecstasy leaking upward
> the vertical is turning horizontal, it is the ecstasy of a fall
> the head rotates 90
> then 180
> a return to animal geometry

Rosalind Krauss: "to disorient the human axis from its vertical alignment—eyes, then nose, then mouth—to a horizontal in which, curiously, the mouth is now uppermost." This is how Bataille conceptualized the evolution of the human face, the contingent mask that replaced animal geometry with the mouth displaced onto the face, instead of a straight "prow" at the end of the vertebral column. For in the case of the animal, the mouth is like a needle stitching up the body, a straight dark tunnel with light at two ends.

Dalí finds out through his photographic collection of heads of women:

falling
falling
falling

pain and pleasure
ecstatic states administered
and the head tilts up
human structure is retracted back, lowered
back to animal geometry
falling
is a release into a geography that undoes the human form
contingent sites evidencing the formation of shapeless matter, faces
like worm kingdoms
like termite music
conceptual matter that knocks meaning off its pedestal
down into the
low brow low
of fallen worlds
The formless mess that remains at the dislocation of geometric coordinates

the de-face

"Defacement is like Enlightenment. It brings insides outside, unearthing knowledge, and revealing mystery. As it does this, however, as it spoliates and tears at tegument, it may also animate the thing defaced and the mystery revealed may become more mysterious, indicating the curious magic upon which Enlightenment, in its elimination of magic, depends."

Notwithstanding the peculiar order of mimetic-technical progression described in *Sathapatha Brahmana*, faciality in humans retains its character as the singular link between sacredness and sacrilege, as also attested by the words' common etymological root *sacer*. Sacrificial cut with entrails like emojis, flowing out uncontrolled, the fingers of a

frxntxc sxxtxr ejxcxlxtxng sxlxr cxm

the slasher^ cut
that looks back)like a grin(())
teeth played ▪ like piano keys
Cut says no™
the cut grin$↫↫back
cuts emitt¡ng∕c´uts
c}u}t}s infesting crawling::::buġ-like¤¤¤¤¤million¤s¤¤¤s¤¤sss¤
ca͵ught by gravit´¡¢¿»×y falling back into »»»»{{{{{{{{{
the corpse𝒞̃˚X𝒞̃˚𝒞̃˚¬𝒞̃˚its original hom͟e...•□¬
th¤e ""″h¬¬¬o×meless ´w•ound ″wa´nderi´ng
gr¤tesqu◀►e̯ grin ´as the
m∆∆sk´¡ ´across tΠe ´f√ce of ©nlightenment
the ´nœ®eactionar√ gri{}n
beaming ba~~~~~~~~~~~~ck at
reason ‰ⱺåˋZZ͵ßßX¬¬¬¬œœΣÉEçɍÍçÎÍf ´
defac•ed

MOCHU

"For the face itself is a contingency, at the magical crossroads of mask and window to the soul, one of the better-kept public secrets essential to everyday life."

SONIC SPLATTERATURE LP #2
THE LOLCAT VECTOR: GRIN ECONOMY AND GLYPH REVENGE

Memory taking shape as a rancid bureaucracy of wounds in the Xenomorph's carnivorous ridicule rapidly transforms into the grotesque laugh of the lolcat on 4chan. The ferocious fertility of the alien superglue-spit repurposes the face of the host as unwilling genitalia and node of infinite dissemination (or *de-semen-ation*), giving rise to a grin that stays long after the prey is exterminated, disembodied like a shining pearl. The madness, however, really starts when the grin itself then becomes a mask. The operations of the Enlightenment themselves are leveraged along this double strategy of negation and visibility. The Enlightenment has always been accused of consuming myth to vomit disenchantment, but since consumption never ends and continues to advance into the corrosive domains of decay and putrefaction, such pungent recoiling only revealed more myth when its vomit particles were devoured with relish by an army of scavengers logged onto the darker servers.

This transformation is marked by Facehugger's own upgrade into the lolcat meme cosmos, which finds its precedent in the mechanics of the Cheshire Cat and its disappearances. In Carroll's narrative the body of the cat disappears gradually, but its grin stays back, floating above the branch of a tree. The grin turns monumental in its recalibration as pure glyph, with only the atmosphere to hold it in place. As a mark that indexes the pure invisibility of the face, it also becomes a crucial monument of sacrifice, with the grin as ritual residue. Faces, too, like monuments, are the most invisible of things. And due to the grin's lack of dependency on any supporting facial muscles it has been more presciently referred to in contemporary times as a form of *scar-ificial* intelligence, a thought container articulated

in the negative, laboring in multiverses of the minus. Taking cue from this ancestral grin, the lolcat animates the grin-to-glyph axis through a steady stream of rhizomatic mockery online. However, unlike the singular glyphic monumentality of the Cheshire grin, all cats tagged under the lolcat memetic order do not actually grin or do anything humorous. It is the entire metadata of all lolcat memes that collectively forge the grotesque flesh of the lolcat grin, thereby conjoining to form a pineal eye for the internet itself. The memetic pineal eye is an eye made of teeth, a mushrooming enamel bomb, blinding white with chattering vision. Animals have the last laugh over the humans. Sacrifices erupt in shrill lolspeak reverb mania as a glorious immanence with the sun is achieved through the clanging of internet communication satellites in orbit during their group sex with space debris.

The grin as memory, excess, and flamboyant albedo-retaliation (albedo: the final stage of chromatic consummation with the sun at the level of pure white), is, however, more fully realized in the electric paintings of Louis Wain, where the cats grin even through their fur. It is a diaphanous entity, the grin, the stuff of swarms shimmering the cat as a whole in prismatic segmentation. In fact, to be cat is to be grin-all-over. Wain's cat-bodies perhaps get possessed by the grin in such extreme frenzy that they are imprisoned and unable to disappear, although his earlier cat illustrations in children's books do have uncanny half-smiling cats brimming with imploded laughter, a phenomenon that might be characterized as an *abject lolcatastrophe*. Through an extended Cheshirization (or transphonologization, if extrapolated to graphic "meow" vocalizations in memes), the brilliantly spiky pigmentation at play in Wain's works, in effect, does not let the cat segments evolve independently; they are strung together into a psychedelic *whole-catness*, like a deft act of micro-puppetry. The entire canon of works by the artist may therefore be seen as diagrammatic solar speculation, carefully developing the figuration of the pineal eye through a domestically bred feline grin constellation.

THE INCREDIBLE VEDIC CHILL OR A FOUL LUMP IN THE (ANT)ARCTIC

An electronic howl rattles the snow as Portas, Tilak, and Smith zoom through Antarctica on a sled-like vehicle. In the vast crystalline expanse, the sound is both blizzard and whale, caverns of ice instrumentalized as leviathan flutes by the atomist propellertech operating beneath the visible surface. The speed is tremendous. Flitting between the polar extremes of Earth is no slow business—they had started off from the North Pole just a few hours back. The message that brought them here was urgent and hopeless in tone, unprecedented for someone like Serrano, considering his long and dedicated career. Their high-resistance black suits and helmets glinting in the luminescent Antarctic sun, the trio steps out of the

high-speed vehicle and walks toward Serrano's camp. Even after centuries of familiarity with the vastness of snowscape deserts and the phenomenological delirium they induce, the explorers are still unable to gauge the depth of the pit inside which the camp is located. Stumbling rather clumsily down, they see that the camp is charred black, burnt particles suspended in sludgy water frozen back into ice over the days. The scenes inside are gory. Human bodies bent out of shape like they're made of some ductile alloy of alien tissue. Whatever happened here happened rather recently, realizes the stunned group. The entire station had been exterminated perhaps just a day back, or even a few hours. More than the sheer fact of it, the technique of massacre is what gets them, the sort of elementary pulpiness of it all. Nothing is solid except the ice that coats everything, even the scrunchy meatoid brittle stuff that oozes and bleeds and sizzles and steams in libidinous contagion all over the greasy ground. Disease is here; they sense countless pods of sentient pollution bubbling about unseen, stuff without genesis or trace. After a disorienting few minutes that seem endless, the explorers' attention goes to the chair at the far corner. The chair that drives the final nail into their nerves, with its orange paint shining strange shapes ... the chair that is itself face, skin, and body all flattened into some archaic projection of forgotten socialism from the distant past ... But in the most literal sense, the object itself is their friend Miguel Serrano.

The expedition had begun on a grand note in the Arctic. Taking cues from her 1940s visit to the sun temple at Externsteine and the cultic rituals executed to great precision there, Maximiani Portas invoked huge *yogic* energies to lay out a giant grid of archaeological apparatus in the snow. Drills, cranes, Borromean ring gears, tessellating spider swarm robots, refinement vessels, needle-point granular digger bugs, wiry mesh micro-cyclones, all swung into action immediately in search of artifacts, charged by the energy of the unfolding subtle body serpent coil. Bal Gangadhar Tilak wrote frantically. As he mapped the slow collapse of the British Empire in India, the mega-journey of the subcontinent's ancestors from the poles

to all the way across the Himalayas became a necessary plot element to build the case for Hinduism as a concise religious entity unifying the country against the colonizing regime. In line with his untimely friends Powell, Blavatsky, Holey, and Landig, his claim was dependent on the cryonic imaginary of ice, the permafrost fantasy of indefinite preservation of pure blood lit by the rays of the midnight sun and its vampiric reanimation by Men against Time. Portas had already detailed out this agenda, differentiating the tasks of the three generations of time ruled sequentially across Hindu eons by Men in Time, Men above Time, and Men against Time. The snowy peaks of the extreme north of the globe, which Friedrich Schlegel had described to Tilak over the phone, represented nothing but the fantastic desire for Meru, the mythical mountain of the original Vedic ancestors. With reference to Herodotus's early name for Medes and Persians—Arioi—Schlegel had done an etymological fusion of the root term *ari* with *Ehre*, the German word for "honor," arriving at the defining term "Aryan" for the Indo-Nordic master race under construction, the monumental projection of an aristocratic collective that would rule over all mankind. Their submarine Atlantean ancestry conjoined with the oceanic imagination of the Vedic seers in the vast cosmic sea of the Milky Way, visible from higher altitudes as a colossal dash of granular brilliance. The Vedic texts saw themselves as an interlinked series of observatories whizzing like speedboats braving this alien sea, equipped with mind-lenses refracting concepts across multiple dimensions. Tilak was in direct communication with these remote telescopes that relayed to him crucial data predicting the final routes of migration taken after dismantling the observatories from their metagalactic oceanways, some groups moving from the poles down to the tunnels of the Hollow Earth, some to the Australasian archipelagos, and others to the northern Indian plains, to eventually spread among select populace these pellets of extrahuman genius. Now he was back here to trace it all out, the remnants of those glorious civilizational antiques, the mineral jewelry of pure intelligence. The archaeological dig was significantly

assisted by Hélène Smith's Martian script, which unlocked the necessary cross-section views of the ice to decipher the exact spots for deep drilling. Smith had pointed out that since the geological formations on Mars were larger than those on Earth by many orders of magnitude, it would make sense for the machines to initially be trained on visualizations of that scale before beginning work in the snow. The overbearing scientific logic behind this conviction being indisputable, Portas set the drilling machines onto a noisy overdrive of Martian language training, rhythmically complemented by the trio's dissonant inner-blue-tick-meditation interludes. But being rather densely involved in the economy of populations largely dead, the overall archaeological methodology of the team, along with these meditation moves, was more fundamentally allied to seance procedures. Seances, for Smith, were the ritualistic parallel to mechanical cross-sections, exposing n-dimensionally sliced views of specific chunks of temporal overlays between the living and the dead. Seance gatherings and the intoxicated states that accompanied them were therefore an alternative platform to negotiate with absent populations differently from the colonial-institutional currencies favored by archaeology's necrosphere. She saw the machines laid out in the snow as a form of medium-engineering rig that facilitated a burial-turning of fossilized matter through a sustained release of "ectenic forces" across subterranean composites. Their exposed system of connectors, screws, joineries, wheels, gears, tanks, fingers, pumps, nipples, separators, pistons, eardrums, pipes, pimples, wires, clitorises, generators, pancreases, and accumulators made visible a flow of forces that deconstructively mirrored the operations of the human body and its hidden mediumistic impulses, thereby relocating the narcissistic attachment to the body onto xenoplanar analogues out in the landscape, in geological layers, in outer space, or in discreet heterotopic externalizations. The orifices of Earth would release its "psychodes" first as vapors, plastic paste, bundles of fine threads, membranes with swellings or fringes, or a sticky stream of gelatinous substances that would erupt out and harden into diverse ecosystems of material objects and organisms. Subterranean impulses of descent and

ungrounding pervaded Maximiani Portas's writings as well, penned under her adopted name Savitri Devi, in her grand 1958 treatise *The Lightning and the Sun*, where Adolf Hitler is a descent-derivative (*avatar*) of the Hindu god Vishnu. The thrust of this southward move from the Heavens to the Earth merged right into the evergreen theories of Nazi underground bases in Antarctica. Flying saucers of the Reich occasionally seen sunning about with seals and penguins more than validated such claims with ample historical rigor. Nevertheless, due to Smith's unconventional interventions, a lot of the time the digging machines had to adapt to the landscape randomly flickering into Martian terrain, with dizzying canyon depths, maddeningly high rock columns, and red snow becoming a standard for the entire station over the later months. The dual speeds of sound on Mars expanded the phonetic possibilities of Smith's glossolalia, placing its complex structures of hidden meaning into a neat temporal perspective, cutting across the vast cross-century communication data processed in her seances. Particularly revealing within these altered sonic possibilities was the fact that the sound *f* that was missing in all her languages while on Earth was clearly audible on Mars, which in turn opened up a whole lot of details on her incarnations as Marie Antoinette and the earlier Hindu princess Simandini. Dog-like creatures with cabbage-shaped heads would even run about collecting any leftover *f*s in the red terrain. In fact, the speeds of sound on Mars were actually what alerted her in advance to the cruel fate that would eventually befall their friend Serrano. For a long while, the diplomat's regular updates about the Antarctic camp combined with his streaming Latin American musical grooves and hypnotic Patagonian vacation vibes had kept them going in good spirits ... until now, when the very last message derailed all their plans.

The chair emerges out of the body of Serrano, who is himself just an organ of the chair. The Cybersyn chair. The optical effect is exhausting—to simply make out the object from the diplomat. It had already been rendered a nemesis inside Serrano's psyche after he was dismissed from Chilean

embassy postings by the newly elected President Salvador Allende. And now the chair makes a comeback to take over his entire body, the body now pliant and indecipherable in that sleek mass of chair-like fluidity and bizarre contortions. The trivial political history involving bureaucratic postings aside, it is only Hélène Smith who is able to see the chair itself as a form of code, to make out the role of the essentially *spinal* nature of the Cybersyn arrangement. Cybersyn posited the entire economic network of Chile as a Ballardian spinal landscape, the futuristic chairs in its central control room homeostatically regulating feedback from large-scale nationwide industrial operations. The chair exemplified speedy decision-making as a *postural function* within operations research and viable system models. For his part, Ballard, in *The Atrocity Exhibition*, had gone so far as to suggest: "In the post-Warhol era a single gesture such as uncrossing one's legs will have more significance than all the pages in *War and Peace*." Subsequently, the volatility of financialization had, already by the 1970s, been recognized by Stafford Beer—the principal architect of Cybersyn—as being contingent upon the postural and gestural possibilities afforded by the design of its chairs and the modernization impulses of their screen buttons. However, the true import of Ballard's statement was only realized a year later in Europe during the preproduction of Alejandro Jodorowsky's *Dune*, when the possibilities of spinal affirmation in chairs arrives at its grotesque pinnacle in the Harkonnen chairs designed by H. R. Giger. Having been just a year since the military coup that shut down the entire Cybersyn project as well as Allende's government, the timeliness of Giger's design is so striking that instead of Harkonnen, the chairs might as well have been used by Augusto Pinochet. A plausible alternative, especially in light of the fact that the film itself was never completed by Jodorowsky. Miguel Serrano, however, might have been privy to a different symbolic order altogether, something that saw the Cybersyn project in general as an antagonist in a battlefield of spines, considering that his initiation into the Chilean esoteric order by Hugo Gallo in 1942 had as part of its allure the vertical extraction of *kundalini* energy from the

base of the spine through the several energy centers (*chakras*) of the subtle body to the crown of the head, to awaken the superconscious ego. After being disillusioned by his early allegiance to communist ideas, Serrano was advised by Gallo that war could even be fought on inner planes, with guidance of the right kind, particularly from the German initiates of a mysterious Brahminical elite residing in the Himalayas, who practiced techniques of ritual magic and *tantra yoga* for the achievement of mystical unions and visions. In the numerous journeys across the Himalayas during his diplomatic service in India, even Serrano had elaborated upon a heavily Orientalized understanding of the same powers in his book *The Serpent of Paradise: The Story of an Indian Pilgrimage*. Linked to crude misinterpretations of Nietzsche's "will to power," and plain Fascist activism, these ascent experiences interpreted by Serrano converged into conflict rather directly with the technologically framed spinal diagramming visible in Allende's cybersocialist vision.

Tilak is struck immediately, struck as if by Thunderbolt. For by the grace of Thor, this is Thunderbolt itself! The *vajra* of Indra! The diamond weapon that released the human race from the serpentine monstrosity Vrtra, or Jǫrmungandr. He can almost smell the *soma* leaking out of the pores of Vrtra's battered corpse ... Wading through the muddle of Serrano's blasted excavation premises, he beholds the spinal column exposed in all its greasy grandeur. This is by far their greatest find, the sacred tool emerging out of the whiteness of snow, he thinks, something that will seal in stone (or ice?) the sublime truths of his magnum opus under construction, *The Arctic Home in the Vedas*. This would be the pillar of unity, the final assault to incinerate the will of the British monarchy currently flailing in its effort to suppress the Indian nationalist movements.

Ignoring the skepticism and unfamiliar sense of malaise creeping upon his companions Portas and Smith, Bal Gangadhar Tilak prepares to take the spine back out to their base camp in the Arctic. But as time passes, they realize that it is hard work even dragging the spinal column out of the pit, its physical

limits so unclear that soon the exhausted team becomes almost unable to tell the pit itself from the spine, in much the same way that the erstwhile chair had successfully mesmerized their senses into perceiving its own spinal character in isolation. It starts with the absolute silence of the spine, in the plain sense that all that dragging and moving and bumping creates no sound at all. If one goes by the basic logic that the amount of sound produced by any object is inversely proportional to the efficiency of its functioning, this thing would be extremely efficient at whatever it supposedly does. The absolute sonic stillness begins to get unnerving, not least because the explorers soon are unable to hear their own speech. The spine has some invisible field around it. They would have easily assumed that they had all lost their hearing if not for their clear ability to hear the wind and the other machines clacking and whirring around them. The wind is as if dislocated around the object, broken without its howling presence, crawling about like a domesticated reptile inside the pit. Or is it outside? The pit is somewhere else. They themselves are somewhere else, talking frantically, repeating words to make themselves heard. Heard over the silence. They hear the ropes, the sheets, the robots, the synthetic fastening devices, all suddenly pronounced and clear with acute sharpness—but they hear it *elsewhere,* far out in the snow, up or down, alive or dead. No number of complicated archaeological apparatus at their disposal is able to grip the vertebral formation in any manner whatsoever, all losing control over basic three-dimensional coordinates at the very instant of their contact with the calcified surface of the object. Confused, the three listlessly circle the pit and the camp, preoccupied by a never-before-known fear of losing all the sounds of one's own body, and just to prevent it they begin clapping, hitting, and punching surfaces, testing if sounds can be made through these noisy gestures of helmet against concrete, shoe against metal, leg against crunch, chew against bark, while also trying to differentiate their own body's sound from that of the surface being hit, just to make really sure of the fine-grained edge at which one body's sound stops and the other body's begins, and many many other such obtuse

measures that just turn out to be a colossal damn waste of valuable expedition time … The camp itself is nowhere to be *heard*. At times their expedition seems to be deep *inside* the spine, along with the pit, Tilak's book, Portas's Hitler *avatar* in the making, Smith's Hindu empire, and the entire fleet of Nazi flying-machine stations hidden in the subterranean Antarctic, all of it just a fibrous speck on the intervertebral disc on this single column of bone. A significant flip of levels is when they realize that the entirety of the Antarctic landscape has now a different sound from its own, native sound. There is a hijack going on. The geological history of Antarctica arrives scrambled to them. The splashing volcanic interiors, the days of quiet greenery, the iceless black rocks, the dust storms beating down on the vast expanses of the continent back in the day. The redness. The exhaustion. The ocean rising up as a blubber wave, coating fat over them. In effect, the Serrano-Chair-Spine-Pit reveals itself to be a nightmarish continuum of sentient organism, technology, and space, all at once. Insufficiently informed as to its structural, psychological, or pathological nature, the team is suffused with a slimy sense of contagion upon bringing it to their base camp at the North Pole, after getting past all that horrid audiotectonic gymnastics back in the south. In this respect, thorough familiarity with Martian soundscapes via Smith's seance training had at last come to their aid. But even in the Arctic, the invasive diabolism of the spine is not contained by any means known to the team, its quarantine possibilities already severely compromised by the very fact of it being spatially ambiguous, or, rather, it being a kind of space all by itself. It might even be said that space in general held no commitment in relation to that entity: it exited and eloped of its own volition, with a good degree of dimensional independence from the column's feral boundaries. It is only when Smith's Martian communication gets interrupted that they begin to finally accept the power that the spine has gained over their voice and movement. Jerking movements, spasmodic expressions, smiles spreading unevenly along upper and lower lips, hair and skin defying gravity, some odd malleability overall … things don't seem all too right.

Smith's regular dance sessions in the camp as the princess Simandini begin to appear increasingly puppet-like, sliding into an automaton-style loss of agency, replacing the sense of liberatory spontaneity that had characterized them earlier.

Insofar as the mouth and vocal cords of the human body are a catastrophic clustering of disasters emanating from the postural rectifications made against Earth's gravity and the physiological migration from animal domains, the grafting of the *vajra* from sage Dadhichi's spine in the Vedic myth of the Thunderbolt is the earliest recorded weaponization of the primal crash site of geology. In the course of its pliant evolution, the human posture also indexes the container function of the mouth and its relocation to the realm of faciality, carrying over the ancient vibrations of accumulated tectonic trauma, resulting in the shaping of its cave-like sonic architecture entangled with the vocal cords. The chthonic spatiality of the mouth and its powers to activate grottoesque thresholds through the chewy-crushy-slicy agenda of teeth are evinced in the colloquial term "roof of the mouth," used to indicate the palate area, with historically deeper symbolism traceable through Anglo-Saxon "jaws of Hell" imagery. The decision to surgically extract the spine to battle Vrtra points at the guttural recognition of precision-warfare potential in the realm of noise and vocalization. The extractive geological prehistory of vocal formations and their thoracic transmutations are indicated clearly in the carbonaceous articulation of the weapon in its original Sanskrit nomenclature as "Diamond." But the complete power trajectory of this lethal invention, beginning from the depths of mineral ancestry and progressing into the chaotic nonlinear dynamics of atmospheric weather systems, is brought to perfect etymological double edge in its collusion with the title Thunderbolt in the Rg Vedic corpus. At a purely visual-semantic level, this trajectory even anticipates Saiva *tantric* formulations of the serpentine *kundalini* energy (or *Shakti*, the divine feminine energy) that rises from the base of the human spine and arrives at crystalline enlightenment at the *Sahasrara Chakra* on the top of the spinal cord. *Nirvana* is the move from Newtonian diggery in the mines to Lorenzian attractors in

phase-space. Mirror-butterflies and Mandelbrot gardens. Vrtra disintegrates as chaotic weather. The monster's wounds burst open and divine beings run about to drink psychedelic pus. "Please do not hold your noses," announces the meteorology station. A foggy mood hangs about, with intermittent slurping sounds in the carcass darkness. Not too differently from Smith's nostalgia for the Hindu princess days, blatantly Orientalized depictions of the occultural powers of "primitive" societies have, in more recent times, attempted to acknowledge the subterranean roots of the disaster trail constituted by the spine, the thorax, and the mouth, particularly as projections of sonic violence. Deriving from the dentistry collages and paintings of Francis Bacon, with electroacoustic music highlighting their sonorous qualities in Jerzy Skolimowski's film *The Shout*, the close-up shot of an overstretched mouth with cave-like insides is shown at the moment when a sonic grenade is demonstrated in action, a technique for "throwing the voice" so powerful that it could kill any living thing exposed to it. With its origin ambiguously attributed to Aboriginal Australian Shamanic sources, some details of the technique may be extrapolated backward from the sensation-figures of Bacon scattered as referential props within the film. The sound irrupts into the body (tunneling despite barriers), smashing it from the inside, thereby wounding without any visible puncture on the outside, like in the case of the dead bird, sheep, or shepherd in the film. The insides are caved in, vibrated into pulp, or restructured in accordance with an anatomical tensegrity astutely plotted in Bacon's works. The body is made into a series of thresholds freed of homeostatic regulation, sometimes appearing as an intermittently flickering abyss of whimsical organs, or, provisionally, a screaming mouth amphitheater overcrowded with cheering teeth, thousands of them stacked in dense layers. The deregulatory operational methodology of the sonic weapon is made further evident over the longer course of the film, when extended psychosexual effects overrun the protagonist's family, as if they are aftershocks left over from that destructive sound.

However, the formative Vedic supremacy of the spine had already been grievously violated by the time the explorer

trio had discovered it in the pit. The thing turns out to be a malignant defilement of the original mythical object they had in mind. The Spinal Bezoar (or the Ventriloquial Thing, if optimized to Martian sound speeds), as the team begins to call it, seems an alien "lump" that had extrinsically started to carve confounding perforation-operation pathways within the spinal column, thereby imposing hitherto unknown regulations on its functioning. Either the aggressively invasive unit had fused with it, or else the whole of the spine is only a radical illusion produced by this malignancy. Tilak desperately remains resistant to the latter possibility, despite the mounting skepticism of his flustered team. Their vocal cords were hacked by the Spinal Bezoar and their voices repurposed to commit to "altogether different biological promises," as Tilak liked to phrase it. Portas also observes that it is not a simple dislocation or theft of voice that the entity is adept at, but that there is a distinct sense of "indigestibility" that characterizes it. This resistance to chemical and acidic assimilation, while also forcibly arresting the program of the spine and its tectonic history, becomes one of the most formidable strategies of the Spinal Bezoar. A term ordinarily reserved for indigestible masses or condensed lumps of foreign particles collected in the gastrointestinal system, the bezoar has a long history of being considered a universal antidote, capable of neutralizing any form of poison, which had gained it a whole roster of additional qualities in old occult literature. Particularly trichobezoars, or undigested hairballs (usually a result of Rapunzel syndrome), are still considered rare artifacts akin to precious stones in New Age circles, commanding rather high prices. The Spinal Bezoar's powers are, however, bilaterally divergent in deploying both ventriloquism and indigestibility as dual tactics on tangential planes, with the former enabling the ability to animate its victims and the latter generating a foreignness that *moved* one through asynchronous emotion. An affective macro-state? A macabre puppetry is set in motion, "plasmatic" in the Eisensteinian sense of cartoon stretchability, and Thing-like in its remorseless annexation of bare organic tissue for further remodeling into comic-horror meltdowns. With their torrid

stream of surreal aggression, cartoon-physics rubberybloops, the disturbing promiscuity between elementary material states, and phantasmagoric spillovers between oneiric-waking selves, the expressive-mutative power of animation techniques in children's cartoons has always served as a blueprint for remotely modulated subjectification, fertilizing both phobia and philia of mingling biomass. While the degrees of movement and stability calibrated across the kinetics of animation cels mirror the protocols of obedience deployed among workers in factory assemblies, the differential pliability of unknown bodies across spectrums of alienness are also cause for irrepressible fear. The problem of the foreign body comes down eventually to its threatening vitality; the swift mutability of energetic axes and the expressive virility of alien tongues and immigrant bodies together form a perpetual rhythmachine jamming with global capital flows. The otherness extends even into the world of the dead, as evinced by animation's complicity with its overlively and meddling nature. Inhuman homeostatic rhythms pervade all factory floors. In fact, it is an elasticity open to the radical double potentials of animation-vocalization that most acutely characterizes the undead, the alien, the foreigner. There is no such thing as a static immigrant, or a silent immigrant.

The explorer trio had never felt as close with one another as now, enslaved together in this marionettric subjectification as threesome claymates without essence. Victims of some fugitive magnetocaloric abomination from nether! What might have in a different context hinted at the materialist possibility of revolution implicit in the "agitative" potentials of raw matter had now been seized into a position of automated obedience to external instructions, or *xenosignalling* from remote centers of control. The neurotic theories of Indo-Nordic racial supremacy and Oriental abandon already under incubation in the numerous intellectual currents backing Portas, Tilak, and Smith's expedition were now themselves subject to a new physics of distortion that threatened the trio's efforts to the point of elimination. The situation isn't good. Hélène Smith's torso explodes in a spray of alien phlegm-goo, and the princess Simandini's head emerges

out of the sticky mucoid geometry with spider-like legs sprouting out of the tissue-studded cabbage neck. The creature scuttles out of the camp at great speed, spinning the entire structure in a web of poisonous Martian script-spit. Despite the shocking loss of their royal companion to revolting biomass, Portas and Tilak act unfazed, escaping their sabotaged tents rapidly and mobilizing their high-tech vehicle. Floating a while later among red icebergs under the dazzling Arctic night sky, and communicating through telepathic song in place of their lost voices, they attempt to analyze any possible steps ahead, given that both or at least one of them is for sure now already infected by the Spinal Bezoar that now chuckles like the pineal eye in all its debauching spirit. The tragedy weighs heavy, and the vibes are all wrong. In fact, it is some unknown vibe that took over and ruined their expedition and the fossil evidence of civilizational scale, all that past glory gone to hell … Vibe is what animates, takes control of their voices, that makes them robotic instruments of … what? History? Spirit? What Hegelian horrors! Back in Antarctica, floating clustered in Serrano's abandoned station, was an atmosphere of ambiguity and cloudy indeterminacy, and the encounter was with pure emotions devoid of either subject or any material matrix to rein it in. The influence it had on the chair, on Serrano, and on themselves was weird due to its nonindividualized nature. The striking animation powers of the Spinal Bezoar, effected through its revolutionary techniques of permeation, hinged on precisely this ability to churn matter along the lines of vibe, without individual subjectivity or psychic locus. In quite the same manner as computational organization under platform capitalism, vibes subsume the subtle tectonics (vibratory layers) that cries, laughs, thrills, and mourns through individual humans with all their complex selves into a larger collective simplicity. Insofar as the ludomania of online reactionary politics has unfolded in tandem with algorithmic surveillance capitalism and the machine-learning protocols that enforce its hegemonic structures, the Hyperstitional spillover of memetic-shitpost-violence into the real world could be said to constitute a pestilential reterritorialization of history through vibing.

Affinity and coherence across platform terrain is primary, regardless of the degree of difference in particular elements, whether Wojaks or Pepes, Gamergate or government spyware. The tendency of cross-platform vibes to move "real" people into "real" actions is the very same power for sinister agitation of matter that is central to the mythological deployment of lulzymbolism across universal memetic panorama. All of history, for Portas, Tilak, and Smith, vibed as an atmospheric "wholeness," party to a unified civilizational destiny, the pre-analytical, "naive" domain of life without alienation. When the mythical *vajra* is hacked, the corresponding spinal vibes (channels of geological vibration) are hacked too, thereby displacing the geographic "rooting" of civilizational narration fundamentally. A space of possibilities is identified and hacked, and billions and billions of possible objects or events are generated within it, through different settings, with the mechanism staying the same. For example, Marie Antoinette and Count Cagliostro, Simandini and Prince Sivrouka Nayaka, and Mars, Ultra-Mars, and ancient India—all these are regenerated by the Spinal Bezoar through different settings within the extragenetic-incarnation-space of possible Hélène Smith codes reconstructed through ectoplasm sculpting, magnetic fluid irrigation, and neuronal digging. A catalogue of mutation-frames. A morph-library of potential Smith-ness. The Spinal Bezoar taps into this entire sequence of possible states and condenses their relations into a decisively marked series of transmutative threads, sifting through colossal amounts of biological, chemical, physical, conceptual, bureaucratic, and literary metadata involving all geological, technical, and organic histories and futurities of both Mars and Earth. *Contagious* vibes splattering about. "Gradients of Hegelian Unhappiness," as Portas and Tilak articulated the new xenovibe that they were animated by, brought the essentially tragic realization that the dramatic ascension of history into a final and total climax as self-conscious Spirit is no longer possible, or was always an empty premise to begin with. Except, fashioned in the style of the best of contagious entities, it felt more like a chromatically rehashed spectrum of tragic grooves, rather than

a world-shattering dialectical awareness. In other words, the very notion of civilization itself had been repurposed by the Spinal Bezoar as an extended, buffering shitpost. The moment of recognition is darkly comic, in the manner of an old corpse appearing to smile because its face is getting eaten away from the inside. What was assumed to be complete and self-sufficient is suddenly seen for what it is: fragmented and rotten hollow.

Lying motionless on the floating sledge, Tilak's mouth opens slowly, filling up with black fibrous straws. His skin has begun to look pale and bloodless under the heavy starlight, even with the ambient red of the icebergs around. Stretching the jaw open and cracking bone, the fibers grow fast, from the sides of the mouth, through the nose and the corners of eyes, wiry and stronger by the second, buzzing out with more and more speed. By the time Portas sees it, Tilak's head is almost entirely stitched over and pinned onto the sled's surface by the chaotic black lines. They are some kind of antennae, clustered insect sensors, she realizes, but also mouths of some kind, feeders corroding the flesh, dissolving it after erupting out of the head. Within moments, Tilak's head is a spinning fibril-sensor-ball, its movements gently rocking the whole sled. It makes no sense for Portas to mobilize the vehicle and go back to India, or to Germany, or to the Mediterranean; the Spinal Bezoar will take over all the population of Earth if she carries it as infection in herself. Only if their archaeological discoveries could somehow be tunneled back through the Hyperborean nether-highways, using the midnight-sun secretions as liquid fuel, that always delirious slippery blackness … The loss is certainly hard to fathom.

Under the sea, arranging themselves in circles as towering columns in deep blue, the whales sleep vertical, half their brains awake to breathe and the other half at rest. With her speech hijacked, the distributed awareness of waking and dreaming possessed by these cetaceans made it a rather easy choice for Portas to use them as communication towers through the ocean. Nevertheless, her letter transmitted to Roerich is sad and conflicted:

SUBJECT: IS THE KUNDALINI A BASILISK?

Dear Nicholas

In all these years, I could never have imagined that *kundalini* could move backward, that it has a rebound function. Could the serpent retreat downward to the base of the spine? Is this Earth returning to primal mess? In some horrible visions that I first assumed to be a kind of insomnia, but later realized were actually meditation in retrograde, I saw giant towers of steel and glass and plastic and rubber, all melting or crumbling or maybe swarm-infested and eaten by billions of intense bugs. Hong Kong, Singapore, Astana, Dubai, the paradises-paradoxes of our journeys to the East (how I miss you dear Hermann!), now reduced to termite mounds, crawled over by wriggling worm wings, their emoji smiles hardening

with each shard of steel, shiny metal revolution on the go, oh the millions! My mouth is too full. There is no space for the tongue anymore. As I write, it rolls out of my mouth like a grand long carpet, and I dance like those ancient Egyptian frog deities out to hunt down and lick dead all these gross bugs, with hypertext jokes inscribed on their tongues ... those fascinatingly free beings I always associate myself with ... but then it is growing stingers, acidic and claw-like. I think my face is a tentacle. I suspect that, over here, more than our individual bodies, it is the technical milieu, the membrane that separates cultures, that has been ruthlessly ruptured by the Spinal Bezoar. In a typical realization of Leroi-Gourhan's predictions, the cultural returns to the zoological, or in this case, perhaps, the virological. I wish the magical Himalayan snow in your paintings will find some space to bury this Thing. Because,

ultimately, in your quest for Shambhala (the final site of pure Hegelian joy of realized Spirit), and the proceedings of your foundation in the hills of Naggar. It is this membrane that you are in touch with, and is what actually keeps you going in the midst of your flight from the Bolsheviks back home. But quite surprisingly, Chinese and Indian shop owners thriving in the tourist markets of Barcelona, Paris, Berlin, Venice, Rome, London, and New York have unfortunately restructured this milieu beyond our control. One can only wait for the flying machines of the Reich to reorient the force of *kundalini* back to its natural state, but I fear that our own machines will be sold at better rates and improved at greater speeds in those fantastically deregulated millennial markets, maybe in Hwangtak-dong, or Akihabara, or Chungking ... maybe. Who knows. There is already a speculative market actively selling cheap components that

fit future discoveries of Reich vehicles. In my future life—although I have now already become a humanoid squid—I would like to be a modernity pirate, selling microchips in some slum in Okhla. After all, the stone that the Basilisk turns one into is the same semiconductive silicon that makes integrated circuit chips.

This is my dream, my very own Shambhala meme.

xx

Savitri

basi\iskfiles>nicolasroux_savitri

CANISTER OF FACES—
AN ECSTATIC POSTSCRIPT TO THE
LOSS OF CULTURAL SUPREMACY

The pressure of clogged time around old towns eventually weighs on the quality of attention possible in those parts. Everything gets pushed around, squeezed tight to occupy the least amount of space imaginable; things cramp up in corners. And ballooning in the center, humongous, is the stretch-machinery of decay, its nasty drowsiness biting through everyone's wretched suburban flesh. Keeping to the constraint of minimum space, frantic bubbling activity proceeded at the seams of this gluttonous durational abomination. The leprous swarm, buzzing in all its aggression, pinned itself like disembodied pink ticks drilling love, drinking blood. An enormous congress of porosities. In deep exhaustion,

depleted of all alertness, Duur Matter could see massive chunks of debilitating dullness tear away and fall, collapsing in bombs of dust. But this was probably nothing. Much was yet to emerge. Pixels danced about in the nighttime CCTV feed as the rhythmic movement of the technician inside the Archaeological Survey premises became clearer and clearer. Her movement was slow, almost meditative; it had something of the incremental high one might experience perhaps in the measured restraint of a Butoh performance. Her gas mask in straight close-up was a clock spewing its own time, white spray gradually clouding the frame all the while. The pesticides probably were colluding with the swarming carnivores suturing together this backyard pickle of a world. Oh, no, these were no pesticides, not in any strict sense; these sprays were more like *enpesters*, surgical implantation tools to fill the bodies of all the townspeople with pancrustaceans. Chemical seeds meant to bloat inside bodies and change blood into bugs.

Distant news signals mentioned that cybercrime departments globally had already been alerted to the abrupt surge of pesticide purchases on Indian e-commerce sites. But the abnormal event having happened around small towns in central India, with relatively ordinary user profiles, led to no pattern of previously known threat. They left it unexamined. The orders had a bit of variety, admittedly: pesticide-sprayer machines, injection dispensers, and combination chemicals. Ambiguous actions popped up in rundown municipal buildings, abandoned water tanks, garbage dumps, and similar zones so characteristic of small towns. Excessive gear was a defining feature: gas masks, aerosol containers, small tanks, gloves and boots, and all sorts of other contraptions with oddly threatening auras. The spray technicians had moved about in the burning grounds first, incoherently spreading the particles here and there. Already teeming with mildly toxic smoke all day, through the year, the burning grounds had really no practical use of any pesticides, except perhaps to defer the politics of decay on burnt flesh, or to alter the cosmic economics of recycling the dead. Dreadlocked ascetics regularly inhabiting these burning grounds did not seem to

mind. In fact, their ash-coated bodies found some atmospheric comfort in this foggy intervention into their habitat. Or perhaps they had some knowledge of whatever was going on, much better than the rest of the population. Smearing pesticide-coated ash nevertheless would have not been the best of spiritual strategies. The fleshy mass belched into online forums, predictably. Its diseased spore of nerves bunched up there it seemed, in the labyrinthine game discussions, closed groups, and shut accounts. Matter could now see the bludgeoning spirit of these networks, entangled with the promises of parasitism seen in the social media animal mystery.

The following weeks had many happenings. Glass cases displaying archaeological finds and partial relics in local government museums appeared to have become extraordinarily clean. This was sacrilege. Without the regular coat of accumulated dust and its associated signification of bureaucratic apathy, archaeology and museology themselves would have no bearing on history. The exhibits began to appear fake. They shined through the clean glass, ancient time vying for attention within this corrupted present, glinting light off the cheap LED display systems. History textbooks would have trouble getting these in. Groups were breaking into museums and licking the glass cases, and taking selfies. The images appeared, disappeared, and were rehosted at high speeds. The selfies had unusual countenances, characterized by deliberately contorted facial expressions. Matter was right. A rumor was around online, characterized by beaming smiles: an ancient burial site of strange animals somewhere around the Bundelkhand region had been dug out by the Archaeological Survey. There was some fear of madness in all that talk, validating why the site had been sprayed with pesticides. Trailing from the Bundelkhand archives earlier encountered by Matter, the story in general suggested either the existence of a parallel network of investigations or else just the random curiosity of young hackers. The pesticides sprayed by the Archaeological Survey had spilled into the water networks of some of the nearby towns and villages. A thick layer of chemical dust, too, had coated green areas, and a clandestine

network of people addicted to pesticides had been forming around the towns there. The exhibits currently on permanent display at the museum were the sterilized relics unearthed by the Archaeological Survey. Even as plain excavations, the objects were quite extraordinary: their character changed considerably when viewed from different angles, and the officials struggled with their hybridity. Immensely complex shapes occasionally leaped out, startling and exhausting some of the staff instantly, while other angles revealed mesmerizing soft constructions. Closer to fossils than human-made artifacts, they nevertheless carried uncanny civilizational suggestions, possibly due to the patchy stone-like texture coating them in parts, like hardened skin. Distant memories of some hidden cultural treasure or legendary past welled up, which no one could really retain or interpret; it was impossible to isolate artifice and intention from geology and evolutionary trauma. Manifesting well in advance of any epistemological framework that could appropriate them, these objects were perforated in time. Future could leak into them at its convenience, without any commitment to the bandwidth of the past. Shiny, magically exuberant chemicals coated these rare exhibits, and people lost their senses when in the same room as them. Tongues shot out, squeaking over the precious history running away with glorious deeds of the past. Dust was snorted straight up to the pinnacle, and then the glass cases licked clean. In a writhing exercise of intervertebral reptilian transmutation, young people crawled about the museum floors at the exact same pace as the slow technician caught earlier on CCTV. Matter could tell easily that the point was, however, none of this. The final objective was to arrive at the face that most accurately expressed their ecstatic relation with cultural history. In the later selfie images unearthed online, the expressions made were so extreme and distorted that it became impossible to even look at them. It was as if they did not possess their own faces anymore. The bugs had filled the bloodstream.

MOLD OF A
DANK CONSPIRACY

In all of Duur Matter's intergalactic cruises to date, possibly the most distinctive sign of the presence of advanced technology was its minimalism—how little drama there was to its operations. For example, the changes to Dizazel Babyloneon's book were surely made *after* it had gone to print. The effect was rather simple, with the exact node of intervention near-impossible to locate. Significant variations had happened to the central premise and the basic narrative arc of the book, as was evident while examining the printing press. Keeping with the publisher's overarching agenda, Babyloneon had, in his distinctive style, built an epic journey into the Arctic by a team of revolutionary explorers, specialized in occult

archaeology and specifically invested in Indian nationalist insurgency against the British through the mobilization of extrasensory meta-energies of subtle body forcefields. But the ideological scheme behind it was rather blunt in comparison to his earlier novels, and based on some flagrant historical biases and conveniences: to reclaim the allegedly lost power of ancient Hindu thought from its centuries of scattered subservience to "foreign" powers by transforming its original energetic mastery into material strength. Collaborating directly with Foundation Ƨ possibly involved such narrative compromises. Populated profusely with retroactively militarized spiritual figures, the story beamed with smooth scintillating action (no amount of which was notably lost even after its near-complete corruption), regulated by molecular infusions of the teachings of Sri Aurobindo, Mirra Alfassa, Helena Blavatsky, Ramana Maharshi, Pyotr Ouspensky, George Gurdjieff, Nikolai Fyodorov, and many other classic exponents of Spiritualist internationalism of the early twentieth century, with intricately plotted distortions of indological art history as well, such as the writings of Stella Kramrisch and Heinrich Zimmer. Many of these historical personalities were already well known for their anti-colonial positions countering British rule in India, especially through their libertarian lifestyles and community work. Babyloneon's futuristic saga had skillfully reappropriated the characters to plant in them a Hindu supremacist agenda tied into fantastic resurrections of Aryan racial strategies, all of which found a common enemy in the colonial Allied forces. The neo-archaeologists Tilak, Portas, and Smith were the warrior agents at the forefront of this reappropriation. Altering any part of this mega-narrative normally would have been hard work. But it was as if the changes had spontaneously emerged into the finished book, in narrative form, dissolving into the backstory and strategic intentionality of the characters, spaces, and contexts. An infernal subzero entity buried in the snow had now irrupted inside the book, reconfiguring its storyline irreversibly. The damage was considerable. To top off these already deft maneuvers was the perfect assault on memory. Babyloneon, after his hospital stay, could only

remember this altered version of the book, a version he had actually never written. And, predictably, he was surprised at the complete ideological contradiction it was to his famously vigorous political stances. For sure the new wound on the back of his neck had some role in this tightly encrypted process. Even at a physical level, notwithstanding its visual-spatial complexity, the wound was, in all its painlessness and silent neutrality to the body hosting it, a characteristic example of the same high-tech minimalism admired by Duur Matter. In fact, it wouldn't be wrong to say that the wound was also a kind of book, except that it would now write the author's own life while also spawning numerous other books through him in a parasitic chain of reproductive literary contagion. Anxiously lighting a cigar, Matter imagined a whole mass of lacerations, hacks, minor cuts, perforations, mauls, and bite marks languishing in bookstores, ready to inflict themselves upon unwary readers. And civilization as a whole becomes a Borgesian wound library, hyperlinking all manner of wounds past present and future to one another, with every wound a host to all other wounds in the universe, endlessly referring only to their own absolute negative ontology, all the while paradoxically identifying themselves by their inseparable dependency on the world of surfaces, on muscle and skin and fur and bone and nail and hair, some that hosted blistering pain and some that never even touched any neuronal pathways, their real pain only in being subject to the overbearing tyranny of surfaces, the horror of hyperlinks fully realized as the hosting of negatives within negatives unto infinity, the clickless darknet that never was ...

Possible that it was his posture, languishing backward while daydreaming through those delicate rings of smoke, the return to animal geometry lol ... or perhaps it was sheer exhaustion. But how could he not have guessed earlier that this wound was "implanted" exactly where one checks for phrenological markers? At the curve at the base of the skull, phrenology identified raised bone curvatures that delineated racial differences. The ones lacking the right bumps were inferior to the ones that possessed them, or some such

contraband baloney. The Nazis had had their time with it long ago, habitual suckers that they were for wholly skewed measurements and theorems. Unlikely that Babyloneon himself ever gave any importance to this forgotten pseudoscience in any of his books, but now that it had actually surfaced, Matter remembered there had indeed been a few scattered reports of the publishers checking racial physiognomies of some of their visitors at parties by feeling up the back of their necks aggressively. Chances were that some of these visitors might have been undercover journalists who dwelled too close to their activities. In any case, now, in place of any potential phrenological advantage their pet writer might have had, was this geometric aberration, the impossible negative squarely coded onto the flesh like a four-dimensional tattoo. It was a war cry. The spine screaming at its apex.

If interstellar sociology had ever taught Matter anything, it was that for every wayward spine there had to be a corresponding tentacle. Tentacles that moved over nations, Rockefeller tentacles, Serio-Comic tentacles, Churchill tentacles, Red Communist tentacles, Imperial Russia tentacles, Standard Oil tentacles, Imperial Japan tentacles, Great Britain tentacles, Landlordism tentacles, Dollar tentacles, God and the Gorillas tentacles, Prussia tentacles, all eating the globe, squeezing the globe, strangling the globe, with their spherical victim suffocating, stung, and depleted. Upon pleading to their ancestors for invaluable guidance on cosmic suffering, all that mankind got in reply were flopping noises—the true ancestors being shapeless mindless amoeba or some trilobite at the base of the ocean sniffing sulfur in millennia-long darkness. Tentacles stood for that too, for time before time, the Old Ones, the endless that recursively ends in itself, backing up on all that contingency humming about. What did tentacles do? They tentacled. The sickening shaking of the legendary ship beset by dark storm clouds, black water erupting all around, the abyssal gigantism lifting up the vessel in curving acid clutches, the sailors screeching dead, puking while being eaten, all that vomit orphaned on my neck as jewelry, oh my treasure of the sick seas, my hallucination, my beast, my rancid

dinner calamari on this mad pirate boat! you make me sick. The Dream of the Fisherman's Wife, kraken attack, octopus football, Cthulhu, spaghetti fetish; it didn't matter, tentacles are action painting. All-over painting. *Architeuthidae* live drip. All-over nation-states, all-over empires, all-over corporations, all-over politics, all-over communism, all-over capitalism, all-over subjectification itself. They are the true catastrophe, the one not eagerly awaiting any impending doom, but the unbearable catastrophe that has *already passed*. The brain itself unfolds with tentacles. Terrible neuron fangs.

Thinking about the ongoing speculation that the wound inflicted on Babyloneon was from some unknown cephalopod, Matter was almost sure that it had been a *simulated* tentacle attack. There was no real animal involved. Tentacular horror, in its revived Lovecraftian vein, being a cognitive tool to re-enchant a world disillusioned by Enlightenment reason, would, by extension, be in cahoots with pseudosciences such as phrenology as a general measure to keep the irrationality going. But this particular case seemed skewed; phrenological data was being overwritten by a tentacular assault. The wound had in effect deactivated the bump under the skull, if there ever had been one. Now it had become impossible to even look there. Pseudoscience corrupted by horror. Had tentacles already been co-opted by the project of rationality? When did this symbolic shift happen? Or was it just a targeted imitation of tentacularity's slippery dynamism to mock the blather that infested the publishing house's directors and staff? Gathering from the advanced invasive technology Matter just saw in action at the printers, where Babyloneon's entire book had been rewritten remotely, it was highly probable that the wound was a technically realized simulation of a tentacular assault in pure archetypal register. A tentacle that winds back from the future; typical Nick Land slime, but with a spirit of betrayal this time around. In any case, being one of the most dynamic embodiments known of distributed cognition, tentacles as the actual source of assault could still not be dismissed entirely as a possibility; they may just be double grips, complicit in the programs of both reason and madness.

Spectral projections matter. Tentacles doubled as ghostly linkages. Bottom of the sea as bottom of the mind. Lenin's peak tentacle fetish was when the spectral parallels to Big Capital got realized as the crawling potentiality of the First International. Oil pipelines winding through deserts and jungles, French, Belgian, British, and German capital digging the railroads in Brazil and India, the spread of German banks in Argentina and Uruguay; the tentacles took form in Lenin's mind as a direct replica of imperial finance capital. The Second and Third versions of the International also followed the same model, all of them tentacular in their multilimbic reach covering the earth, albeit ghostly unlike the original meaty Capital that inspired its DNA. "Each of the three great workers' internationals corresponds in form to a particular stage of capitalism." They long remained figments before taking shape as organizations, at the time seen by imperial powers as some kind of bodiless terror that needed urgent containing. Specters, unlike the trappings of infrastructure with all the grimy weight of flesh and coal and metal, have the unique oneiric dynamism to capitalize on the future, or, rather, on the freedom to reconfigure histories through subterranean movements in time. The tired refrain on Lovecraft's racism, notwithstanding the evident facts, overlooks the duplicitous tactic at play in this overlap of spectral tentacularity with corporeal tentacularity. In other words, what is missed is the ridiculous merger of formal intensities between the forces of revolution and reaction, with ghostliness vivisected together with the Weird to shape the delirious insanity of Cthulhu's face tentacles. The conundrum of the skulltopus animates this obscene historical concurrence of the forces of revolution with the forces of finance capital through a formal collision of the inclinations of hauntology with that of the Weird. "The outstanding synecdochic signifier for a revenant human dead is the skull—mind-seat now empty-eyed, memento mori, grinning, screaming. The nonpareil iteration of the embodied Weird is the tentacle, and by suspiciously perfect chance, the most Weird-ly mutable—*formless*—of all tentacled animals is the octopus, the body of which, a bulbous, generally roundish

shape distinguished by two prominent eyes, is vaguely homologous with a human skull. The shapes are ready, and take little to combine: the Weird-hauntological monster is clearly a tentacled skull." Spectral tentacle turns human skull, fleshy capital turns tentacle. A vicious wheel, ancient like the Old Ones, its cold indifference incubating in high-pressure deep sea, itself a torpid surveillance that turns one raving mad through mere awareness of its existence. Paradoxically though, the dubious claims of the Landian re-enchantment project shatters spontaneously, given the skulltopus figuration implicit in Cthulhu's facial structure, as the revolutionary spectrality of the Internationals erupts through the very same deterritorialization potentialized by such a renaissance of tentacular horror. "Leviathan with tentacles of steel," as the farmer Annixter describes the Southern Pacific Railroad in Frank Norris's *The Octopus: A Story of California*—not the kind of thing one would want to buck against. The railroad threatens the California farmers as a "great monster, iron-hearted, relentless, infinitely powerful." Yet, intentions remain ambiguous, as there is no individual mind behind the steel tentacles; the railroad thinks itself into existence, its construction being fundamentally a feat of legal-fiction engineering. A figment that has minds everywhere crawling, clutching, drilling, gripping, slipping, sleeping, and dreaming. Dreaming itself into the abyss of personhood, almost. Like the evil octopuses crawling over newspapers, cartoons, magazines, and propaganda posters. The deathly evil eyes locking gazes with potentially sinister intent. But beneath the imagery, corporations have no such traceable intent as such. They become pure tentacle. Pure drip. Somewhat "altogether without a substance," as Joseph Conrad describes the iconic anthropomorphic embodiment of the enormous mythical power of the corporation, the "phantom" Colonel Kurtz. No density of equatorial fauna in *Heart of Darkness* therefore matches up to the insidious slithering of the corporate contract that binds Charles Marlow in his journey into the Congo. The dexterity and power of the corporation's "organs" far exceed the ecological immensity of the tropical geography,

sometimes almost to the point of appearing demonic in a theological sense. The devil himself conversely benefits from this association that results in his civil legitimization, reaffirming the secret root of his supernatural stealth. In the words of the Protestant theologian Daniel Schenkel, for example: "Evil is always personal; there is no evil outside of the self-manifestation of personal life. But Satanic evil is no longer subjectively but *collectively personal*. Satan is a person, juridically speaking: a so-called legal person, a collective person of evil; and this is the source of his, at least relatively, extraordinary supra-individual power." Satanic tentacularity, a distinct vibe of collectively personal evil, an aggregate of people that can never disaggregate. The lunatic horror of Cthulhu mirrors this divergent vibe-coherence of tentacular, distributed intelligence across both corporations and the revolutionary organizations that rise up against them regardless of the presence of any guiding leader or intent-dispenser. Swept in an excess of organicist delirium, the individualized mind short-circuits upon its impossibility to harmonize the levels of neural complexity arising from the fusion of jurisprudence and fiction. Encounters of such incompatible states of being frequently manifest in Lovecraft's tales as unspeakable or indescribable creatureliness that harbors triggers of irreversible psychological derangement in human subjects.

Crowd formations are infamous for their unnerving display of how individual minds shed intentions rapidly in unison, with no determinate provocation or purpose in sight. Elias Canetti calls this "discharge," where large masses of people come to an unspoken, automated agreement toward a common goal at extreme speed by a timely release of differences, a collective abandonment of individual intentionality. A wave-like synaptic intelligence possesses the crowd, expanding and contracting in accordance with the efficiency of discharge. In fact, *there is no crowd before the discharge.* "This is the moment when all who belong to the crowd get rid of their differences and feel equal. These differences are mainly imposed from outside; they are distinctions of rank, status and property. Men as individuals are always conscious of

these distinctions; they weigh heavily on them and keep them firmly apart from one another." The brain explodes out for meat-puppet colonization of the limbic system; the discharge is the becoming-tentacle of human mass. Through discharge the crowd reconfigures the societal limitations on proximity, thereby desolidifying the parameters of distancing between bodies. Resembling some kind of decentralized martial art, it's a form of bonding through emptying. Reproduction or multiplication is achieved through systematic reduction, to arrive finally at the outright elimination of the individuated unit. The peak vibe is of equality. Conversely, the distinctive cephalopod tactic of *discharging ink* as an escape mechanism is exemplary of the way the distancing apparatus of bureaucracy is mobilized as a labyrinthine facade of *inked paperwork*, the Great Chain of Stains that legitimizes all actions of collective persons, of fictional persons without intent and body. Just as the fluid contamination of ink in water enables the liquidity of creaturely presence, the mingling materiality of seals, signatures, bonds, letters, stamps, and fiber-optic cables (regulating digital metadata controls) liquidates the responsibility of corporate personhood. The apex where one expects a singular decisive brain or sovereign calling the shots is suddenly revealed to be a chaotic swarm of multiplicities without any will or awareness of the larger hive of which they are part. The entire imperial-colonial apparatus and its far-reaching infrastructural interventions in colonies, vassal states, and zones of mandate at the turn of the twentieth century were operationalized through the very same Hyperstitional strategy, of finance capital cultivating itself through a systematic pre-incubation of swarming fictions that deploy criminal extractive potentialities that lack identity or essence. This obscurantist program of bureaucratic ink secretion is dialectically mirrored by the darkness of carbon emissions unleashed by industrial capitalism, that, in a slyly contrarian gesture of karmic ejaculation, reveals a formative morphology for corporate intentionality in the nonlinear dynamics of factory smoke, forest fires, oil spills, and microplastic storms.

Martian tentacles suck human blood in *The War of the*

Worlds, where a bigger-scale neural collapse of the singular planetary apparatus of human civilization itself is countered by the more minutely aggregated intricacy of pathogenic infection, as the extraterrestrial invaders die of inadvertent exposure to invisible microbacterial contagion. Martian meat neutralization is initiated through the spectral phenomenology of tentacular germ revolution. The advanced technological prowess of the alien Other gets trumped by the intent-less germ "culture" of the "native" planet. But at a molecular level, this interplanetary battle is a province of co-evolution, of the Weird and revolutionary spectrality. The Martian anatomy in Wells's book, as an earlier version of the skulltopus hybridity that operationalizes human blood as interplanetary resource, also brings to light the skepticism about racial mingling, xenoconsciousness, and colonial extraction so dominant in that historical period, later spiraling out as paranoid pulp tales in Lovecraft's oeuvre. It was the zeitgeist, stuff of the wind. Like the awful stench of salt and fish that wafted over that suburban American afternoon. Shadows were long with the bright orangish sun beating down on the narrow street, clicking with the sound of the approaching donkey hoofs, slow and lumbering in the siesta quiet, carrying their strange loaded bags. Heading them was Ali Baba, in turban and long robe. Up close, he was fully damp, even dripping wet, the air rich in marine flavors. As the bunch came to a halt outside the window, the pool of water collecting around Ali Baba's feet slowly led Jonathan's eyes to the hideous pinkish slime perspiring behind the trader robes. Shiny bulbous spots, lumps, hooks, and hypnotic spiraling formations inhaling and exhaling, breathing all over, thinking through the whole continuum of flesh! Is this an unholy Arab, for god's sake, or an infernal Jew, or some Asian apparition, some slanty-eyed Yellow Peril? The "monopoly" octopus was here, sliding its tentacles out onto the street, slithering across pavements and asphalt, its scheming many-brains all over, crawling. Offering its donkey trusts to the United States, it was a disgust fest, all in all, a soulless carnival of hydrostatic musculature, emerging from some defaced universe pitifully hidden from all humanity. The ink

that it secreted onto the paperwork it presented clouded more than it explained, with all the dubious mercantile exchanges promised. "I don't like your looks, Mr. Merchant, you had better move on," says Jonathan in blatant refusal of the offer. The cartoon is from 1888, drawn by William Allen Rogers for *Harper's Weekly*. The American public of the late nineteenth century sees the corporation as an abomination as unreliable and inhuman as the cunning foreigners milling around their cities, taking away their lands, jobs, women, men; in short, all their wealth ... But at the same time, neither actively *commits* crimes, for they are without a mind, or a soul, like automatons. Crimes possess them hypnotically, their brains multiplying as limbs, robotic mechanical components that plug in and out of all of us, devastating entire societies through off-and-on plug-and-play beep-beep encroachment as refugees, railroads, domestic labor, mills, pirates, computers, or artificial intelligence. Such designs of automatic criminality inform the paradox of Schrödinger's immigrant, who is constantly stealing all the jobs while also being too lazy to work, a timeless complaint oddly coterminous in tendency with turn-of-the-twentieth-century conspiracy theories where Jews were both simultaneously at the apex of extractive finance capital while also fomenting fiercely irrepressible revolutions all over the world. Jewish conspiracy theories share with tentacular horror a common genesis, informed by the consciousness of history itself as a by-product of reactionary war against projected biological difference. Pagan affinities, theological mutations, immortal transcentury criminology, and other occultural abominations ran amok through imperial territories in the wake of the revolutionary uprisings sweeping the world, which in turn imitated the multiganglial dynamism of its n-limbed enemy. The barbarian imaginary both converged and clashed with the working-class imaginary. The sole exception being the people outside of history *anyway,* the people who never qualified for human status, assembled in the vast colonial plantations, mines, law firms, civil-service schools, and military trenches, pulped at the ground zero of the Anthropocene into industrial carbon-mineral mixtape mash meat and smoked

out to Earth's darkening atmosphere. What Hegel called the "unhappy consciousness" bloats to the size of the planet at this ground zero of extraction, where racialized history coincides with an entire geological epoch that positions the human as its transformative marker.

Meteor: *Flashes across sky*

T. rex: Oh no! All that history!

The biotechnological fantasy that civilization could pop up spontaneously without the resistance of history is brought to its comic conclusion in theories of ancient aliens or similar panspermic origin speculations, which identify all of humanity to be of extraterrestrial technological genesis. Sentient extraterrestrial interventions legitimize the presence of evolutionary trajectories that have formed without the inertia of either rationality or circadian rhythm, both taken to be anomalies within the otherwise smooth sweep of expanding civilizational desire. The pyramids of Giza, temples of Borobudur and Angkor Wat, Göbekli Tepe and Catalhöyük, cities of Mohejo-daro, eagle-shaped Vedic fire altars, the Ziggurat of Ur, Toltec pyramids, all spun into a transplanetary Orientalist-techno-theology. Extractive wish fulfillment as meteor spermatozoa. Human history as cosmic catastrophe. The postwar flying saucers of the Reich buried in underground Antarctic bunkers, patiently awaited by Maximiani Portas, are ideological concentrates of this sentiment. Unlike their enigmatic kin in the American Midwest, these are *overidentified* flying objects. Unhappy flying objects. Unhappy consciousness is the scream that no one hears in outer space, or the polar latitudes, or Mars, at that critical moment when the barbarian erupts from inside the colonizer in a splatterfest of imperial defacement. The paradox of the other emerging from within the self is all of a sudden obvious and unavoidable, but still it remains unassimilable, and prohibitively alien. Even so, the scream as such is still too optimistic; the ultimate contradiction at the heart of the unhappy consciousness is the negation of

the scream itself, through its instrumentalization as a form of silence. Outer space *inside*. The devastation in knowing that Fermi's Great Filter, which exterminates all possible forms of history and time, is already behind us, leaving us with not even silence but its dislocated copy. A silence arriving ventriloquized. Irreconcilable subjectivity of the kind that Kurtz calls "The horror! The horror!" The universe is the inconsolable tragedy after the fact. Peak Type III+ supercivilization stuff.

The sound of ax hitting metal, that most intolerable of sounds in the cosmos! But also splashing water, fuzzy voices screaming, and the oddly comforting hum of surf and spray. Thundering sea. Flesh sliced and diced and slippery squeaks on that weird alloy, the exoskeleton of *Nautilus*. The scene was gruesome, a sea battle streaming through Duur Matter's splatterature interfaces, sound developing to such clarity it almost felt like live transportation back to the heydays of empire. Captain Nemo was slashing manually the coiling arms of an aggressive kraken clan that had attacked his ship. Forming the action pinnacle of popular Aronnax lore, the sequence as a whole indicated Nemo's dislike for the imperial metaphors the creature carried in its beastly multiplicity. Never mind that the sheer resource consumption of his submarine was probably more imperial by design than any malevolent sea creature. His desire was really to slash the tentacles on land, the stuff of propaganda posters. Regardless, this meant that the undead junk extension *Zombie Nautilus* would have some discreet interests in continuing this neocolonial battle up on the surface. The sea turning electronic would not affect the equation regardless. Each little wave was a beaming liquid jewel of communication heaven, and the electronic cackling, music to his ears. Two dolphins approached him, their smiles unquestionably endearing in that very aquatic, lost quadrille fashion. Had they been watching Nemo's battle all along? Joining in on such cetacean pleasantries was never his fancy, not ever since he signed up with Be— Wait, what? Something had changed, as if some dead skin fell away. *Inside* his brain. A smog of ideas lifted. This was unprecedented. Here was the entire grid of the case, clear as a sunny spring day in his mind! How

had he misplaced all this data? Of course, this was never a small feud but a huge war between species, across continents, maybe even planets. Cetaceans versus cephalopods. *Zombie Nautilus* was under control of the dolphins. He *built* it lol. Reassembled masses of steampunk tech from the sunken literary wreckage. How could he have forgotten all that dolphin camaraderie! As evinced in the circus performances dominating Dizazel Babyloneon's post-abduction hallucinations, the dolphins had successfully exposed the conceptual limitations of relying on tentacular horror for continuing the work on Foundation Ϩ. Tentacles could no longer be considered simple carriers of impersonal horror; they could be simulated to spin the contagion of revolution, too. And it was already high time.

It was only after breaking into Foundation Ϩ's warehouses that Duur Matter was able to gather the import of intergalactic class wars on their plans. Crucial to this understanding was the startling realization that he himself had been poisoned by DJ Hands Receivers' audio objects. Over these days of the investigation, he was well on the way to being discreetly molded into a TwO extremophile. The dolphin cries from *Nautilus* had jolted him out of the influence. The skin that had fallen off inside his brain earlier was a thick coat of poison. In fact, his entire investigation had been hacked by the DJ's venomous inputs. It had become almost impossible to believe now that his original mission was actually to disrupt Foundation Ϩ's activities and shut it down once and for all. Instead, in a swerving about-face, upon his arrival in Goa, a steady stream of extrasonic TwO inputs had made him work *for* the Foundation. This flip was incredible. And through this process of becoming-extremophile, he was in turn instrumentalized as a link to trace out their as-yet-unknown enemies, i.e., his actual team, all of whom—apart from the dolphins—strangely remained rather fuzzy, or maybe entirely unknown to him even now ... The whole operation had already advanced far. Like a specimen in some chemistry lab, the more poisoned he got, the clearer his networks showed. All the while, his memory had been temporarily erased; there was no recall at all about his actual mission, except the bits coming in

now. However, as of now the battle tactics had been almost set to a draw. Unlike his earlier deluded conclusion, both sides were equally equipped technically. For some reason, the TwO inputs had reached him in a defused form, without the power to control him at the level of ideology, and that is how he was able to terminate this influence. Which meant there was an anarchist counterfeed somewhere, a last-resort immunity kit deployed by his defense team, that finally got him out. How could he proceed, though, with these gaping voids in his memory? The astonishingly complex system of operations across worlds, which he once headed probably, was now stuck in some unidentifiable neuronal blockage. Funny that all these lost memories somehow seemed not really present in his own brain, however deep they may be buried. Or, for that matter, anywhere at all in his body. In fact, it was not just his memory; his body itself seemed not anywhere in his body, as if it had never even committed to the very *project of presence* at all. In other words, it seemed his body was in a state of entropy so extraordinarily high in relation to the arrow of time (past equaling low entropy and future equaling high entropy) that it was entirely located in the future and was, therefore, unrememberable. Of course, this could also be because he was a spontaneously generated brain, or a configuration of matter with complete memories of the surrounding universe, that had emerged due to random particle fluctuations. This thought afforded higher statistical probability than all the current theories on the formation of the universe. But the memories existing within this brain in the present had no correlation with the missing memories, since the particles corresponding to those might have been the result of other independent fluctuations, outside his own brain. In effect, they were unreliable in all respects, having been severed from a body that exists only as pure potentiality.

But as it played out within the period of poisonous influence, there wasn't the slightest awareness of any prompt from the outside. External instructions—in this case, noise-venom—had finely escaped the neurological barrier that detects them as being separate from self-intentionality. In Liu

Cixin's novel *The Three-Body Problem*, the Trisolaran fleet on its way to colonize Earth from its distant planet sends subatomic probes called "sophons" to Earth, in advance of its 450-year-long journey here, with the express purpose of preventing any further terrestrial development of fundamental sciences by humans during that period. Was there any particle that could, like the sophon, prevent the evolution of fundamental components of ideology? wondered Duur Matter. Given enough time, are there particles that could fluctuate into concepts directly? In Liu's book, the 1960s Cultural Revolution in China is the start of a chain of mass resentment percolating through generations, a disillusionment with the promises of class liberation. Tired of the wretched concerns of Earth, one of the employees of the Chinese space program, in a decisively vengeful act, relays radio signals that reveal Earth's fragile location to an alien civilization, leading to the original call to invasion. The signal is an invitation to colonize, and set things right, even if that critical corrective gesture might be the complete extermination of the inviting party. The act triggers a whole chain of interplanetary Darwinism that constitutes the novel and its sequels. The technological superiority of the invading aliens, on which the colonizing potential is hinged, is, however, essentially a product of their biological-natural circumstances. Consequently, this advantage possessed by the invaders is parasitically instrumentalized by the subject race for its own radical imagination of freedom, which is through a collective call for suicidal subjection. Paradoxically, though, it is the Cultural Revolution that sets the ground for even just the scope for such a reaction: the ability to seize the means to suicide at an unprecedented, cosmic scale. Through this act of treason and deceit with regard to collective human destiny, the subject group merges with the technological extensions that result from the invaders' biologically determined advantage, thereby upgrading into a technoparasite par excellence. But, again, the very dependency on the biological superiority of the distant civilization is no different from just bribing a bully. The *a priori* premise is to acknowledge their superhumanity as a given, and then to mobilize it to release humans from

totalitarian bondage. Speculations before the Russian Revolution had probably anticipated this kind of reactionary rebound of racial consciousness in the making of history. Alexander Bogdanov, in *Emperiomonism*, had written that the workers of the world would unite instinctively through an intersubjective human consciousness, and the function of the Communist Party should be to assist them in this through offering political direction and mass education. The means of production needs to be seized at the subatomic level. Technological superiority need not be a function of biologically deterministic exosomatization, but a result of sociologically informed particle interactions. These particle-accelerator ideas powered on the energies of class consciousness got Bogdanov sent into exile when, after the revolution, Lenin won the party (with advice to his friend to just stick to science fiction and not bother with political change) and imposed a socialist dictatorship. Bogdanov's ideas proceeded on other paths, dispersing further through the Trotskyist Internationals.

For Duur Matter, the archetypal three-body problem was condensed in an old photograph of a chessboard around which revolved the heads of Lenin, Bogdanov, and Gorky, because the highest level of impossibility in predicting any revolution was most pronounced with those heads in orbit. Notwithstanding this age-old intervention from the domain of classical mechanics into the revolutionary imaginary, countering TwO ideologies would be logically possible only through technological developments emerging out of class consciousness. It called for a rehaul of technical cosmologies at a fundamental level. Be it alien humanoids, or sentient foam, or zombie finance registers, the superior civilizational methodology was what mattered. Sour dissatisfaction with technologies derived from biological chance was really what set apart the forces against Foundation Ω. It was a direct reversal of the premise of Liu's trilogy. The dolphins' role was becoming clear now, as were the benefits of his own qualifications in Interstellar Sociology and Out There Political Philosophy. For whatever reason, him learning about these interlinks, however belatedly, seemed

to have always been a cause of worry for Hands Receivers and Hormel Python Publishers. Therefore the poisoning. It became evident that whoever or whatever might constitute his original team, Matter's lost memories had as their significant component something of a zombie recapitulation of Bogdanov's ideas, already run through a kaleidoscopic history-shredder by the Argentinian Trotskyist leader J. Posadas and his party comrade Minazzoli as part of their later organizational manifestos in the Fourth International Posadist. Perhaps as a reaction against the expanding power of the competitive technological propaganda of the United States, Posadas saw UFOs as an indicator of advanced civilizational development on other planets and in other galaxies, an evident sign according to him that communism thrived in deep space. Dysfunctional Nazi machines rusting about unhappy in the Antarctic bunkers were no match for the shimmering Communist alien crafts. Victory is already here. Tfw one realizes that Hitler and Eva Braun's postwar vacations in Patagonia were just colorful house-arrest dioramas sponsored by exoplanet socialist museum funds. The question of energy, Kardashev scales, supercivilization sociologies—all an ethereal light beam on a Pampas cow. Spaceship as space-opera comradeship. In a bout of nostalgia in the later days of his life, surrounded by his friends, Posadas expressed the desire to have an archive of his work, citing the history of the International, Latin American politics in general, the Olympic Games in Moscow, and the memories of his family. All these being signs that the world was organizing around the sentiment of socialism. He noted that even birds outside his window were having meetings on the subject. Soon all animals would live side by side in peace. Particularly, the dolphins. "There's going to come two dolphins to my side. You'll see. I am going to manifest the desire to be helped, accompanied and taught by the dolphins and they're going to come." As part of his radical xenophilia across interstellar vistas, Posadas did not ignore local human-animal collaborations, especially with these cetacean comrades always clicking signaling electronic buzzers that they were, always ready for a rescue mission, as they had now saved Duur

Matter himself ... The Foundation's fears about the Posadist connection were probably not unfounded.

> "Wait, it's dolphins all the way down?" asks Astronaut One.

> "Always has been," replies Astronaut Two, gun pointed at the other from behind.

Matter crawled and tiptoed through air vents, secret tunnels, and synthetic-meat freezers in the warehouse. He was equipped with sufficient tactical and protective gear, like insect suction gloves, sonic defense plugs, and anti-noise pills. For once, being appropriate for the pressurized air and cold, his noir costume actually helped. Creeping inverted on the ceiling of a high room, he found himself looking at a rather strange arrangement below. Illuminated by disco balls, strobe lights, and smoke machines, the place was bustling with people. He could make out Hands Receivers, Leon Burp, the publishing office staff, and a few other assistants, but there was no music. They were caught up, writing on paper and transcribing stuff across computers. It was a venom production lab, the headquarters of sonic mithridatism. A curious downside to composing a script for TwO sessions was revealed to Matter here: the source theoretical material had to be written at the speed and rhythm of the flickering lights, but the music itself, being under development, wasn't available at the script stage. The whole thing seemed to be in the wrong order, or oddly off-sync, compounded no less by his upside-down view. Although, since his entry into the warehouse with the special gear, he had eased in so much with the insectoid movement that up or down directions no longer held much meaning. Along with this reduced asymmetry of space, time too was becoming less asymmetrical, which was obviously more intriguing. The present was no longer effective to regulate the flow of events from the future into the past. Even less to sustain their perception in reverse, i.e., to keep interpreting the past in order to grasp the future. Many things were caving in backward, with unrealized potentialities upended to appear like distant

history. The conundrum of the lost memories of his team meant that in all likelihood they didn't exist. *Yet.* Chances were high that a large degree of fictioning was involved. But how far did the fiction stretch, or, in other words, to what degree was he expected to manage time distortions in speculative capacity, such that any concrete results may be distilled from this dangerous mission? Unlike projects set in linear time, collaborating intensively with as-yet-unformed fictional entities meant precise actions based on daily projective estimates. Did the name Bezoar mean anything to him? The only possible clues lay in Babyloneon's new book—its corrupted version. The naming and the behavior of the Spinal Bezoar implied that there definitely was some geological component to the sabotage of Foundation ♎. Catastrophic geological data encrypted into the spinal column could only be deciphered and invaded by entities adept in crunching vast quantities of dusty metadata across the cosmos. Gathering the traumatic vibes of powdery aggregations in this manner, with such empathic sophistication, would be possible only for a parallel configuration of geological matter of comparable complexity. The most formidable enemies imitate their opponent, in acts of precision communion. Matter's splatterature interfaces too had already done the homework, sifting through Hands Receivers' extensive discussions, files, and cryptic research data in search of any mention of any name, any trace artifact or substance, that might help to gain a sense of his own past, even if extrapolated backward from the opponent's path. Footprints of a collective, maybe some elusive anarchist group called Bezoar, some clustering intelligence somewhere far out in the nebulous sewers of outer space. Or a rogue planet that infiltrates the orbital mechanics of the Aldebaran star system, made of something that resembles hair, or fur, hard at its core, and the Great Scramble plays out over a billion years in the dead stench dystopic past of some galactic hinterland. A trichobezoar derailing orbits, an entire planet not digestible by the universe. Babyloneon describing his circus dance as being a form of mining operation now made sense, the Great Scramble being a mega-scale mineral extraction rush to the

follicular core of this planet Bezoar, to enable the manufacture of ideology-particles that would systematically neutralize efforts to develop harmful superintelligences. No more eternal torture simulations. It would be impossible to even think about it. Lol. This was some miserable gossip so typically expected of the impoverished imagination rolling within the Goa camaraderie. Supercivilizations, cloudy squids, spore infections in deep space, all of it just a garbage bundle of phobic morpheoso, dream pathology in action. Maybe there is no group or planet, and all that Bezoar gobble was about the shedding of hair by black holes, information exhaust fanned out of the Schwarzschild radius into our own universe. The anthropomorphism was getting nowhere; the infrastructural bug that was preventing everyone from working and realizing the goals of Foundation Σ was most likely a structural condition of the universe. Who needs ideology-particles when you've got the whole universe? Something about the universe resists both reason and entropy. This is, of course, assuming that the progression of reason aims to achieve a negentropic state, possibly realized as a supercivilization, in which case the current universally operational principle of constant change would be grievously violated. Stability would be too fundamental a correction for the structure to tolerate. Therefore, paradoxically, the universe would resist any form of change to its structural law. A rather conservative situation to be working for, thought Matter, not his usual kind of choice, inasmuch as he could recall his own normative models. Yet, in this case with Foundation Σ, it was not reason that threatened the universe with stability but some sort of pre-analytical, naive projection of mythical completeness. A surefire contradiction, given its claims to awaken vital energies, yet only within the comfortable bounds of low-entropy states, otherwise known as the past. Mythologies devoid of any speculative program, therefore, always indicate *exceptional situations of low entropy*, that hold neither progress nor energy, banally coming across as present projections of historical glory that never existed. Enchantment for comfort junkies. Nevertheless, inasmuch as thinking about

beginning and endings makes any sense, the structure of the universe stays for ever. All forms of extermination plans have been transcended and closed. The very fact that it is impossible to recast the structure itself fundamentally—instead of repetitive acts of pointless exterminations and shoddy extinction acts across greater and greater filters and supercivilizations—is the true bane of the interstellar libertine. There is no crime good enough to shock the universe. This is the bitter curse of subjectivity realized as the inhibition of action, the final prison of nerves. Hegel's acerbic comment to his student Heine that "stars are only a gleaming leprosy in the sky" paranoiacally encapsulates this diseased constellation of boundedness and inactivity imposed upon the paralyzed human subject. Behaviorally inhibited from accessing any final escape plan, nerves negotiate varying stages of incomplete destructions and regenerations, realized as schemes of aggression, through confrontations between psychological, civilizational, planetary, or interstellar forces. The giant hall right in front was padded neatly in velvety pink or red flooring. A texture emerged on the floor at times, grainy, and with an oddly perforated feel, but it oozed transparent thick liquid that flowed from the sides of the room all viscous, frothy, and strangely glue-like. As he walked toward the bright exit, curiously examining the contortions and uncannily alive feel of this unusual space, the walls seemed to converge around him. But was it just his imagination? It was so slow as to put him to sleep in the middle of all these tasks. Soon he was brushing past rows of stalactite-like calcified rocks, both sharp and blunt, closing in, caressing his earlobes and forehead, his million hairs. Sudden bright lights! He was out of Leon Burp's mouth, drenched in the man's saliva, teeth and gums tearing greasy behind. Far in the distance, through the sticky fluid, for an instant he glimpsed the shocked face of Hands Receivers, and the staff around screaming in wild panic. The screams sounded hilariously distorted, extraordinarily slow that they were to his perceptual field. Would take a while to optimize all this. Burp's teeth that he had just slipped past had now begun to integrate with his own flesh, sprouting beneath his

feet like snow shoes. Click clack click clack. These could even sound like dolphin calls. This is no memory, by the way, this is happening live. He sprouted an eye right behind, a bit to the diagonal top of his head-like unit, gazing straight at that high ceiling, scanning the corners, parsing the darkness, and saw Duur Matter hanging inverted on the roof silently, wearing the insect suction gloves. A steep crash into a mad pit, like the worst of vertigo dreams. Hell, he almost lost his suction grip; the drop in nervous-muscular pace was as if he suddenly accelerated into old age. Between the strobe lights and smoke and disco balls, the fleshy lump with clickety teeth-feet had smattered the entire room at mind-boggling speed with a fine-grained shredsampling of Burp's flesh, bone, mucous, and tissue particles. Now shimmering with brilliantly alive hair, it would soon spread to the rest of the people below and his mission would be finished. At his speed, people are so slow they appear almost motionless. He just has to extend his wiry limbs, his tentacles, claws, burst a few ears and eyes, unblock those neural obstacles, merge and merge and merge, extending and voiding through the different layers of subatomic goo-plots. Again a pure mereological exercise, analyzing surfaces and the relations between parts and wholes, cold and academic. Edges, borders, margins, enclosures, containers, boundaries, and envelopes. Is it the surface of the skin that erupts in blemishes, sores, and blights, or is it the skin itself? A head perforated with a million worm cavities. Within the cave that is the mouth, a series of tongues sliced and drilled, interlocked through barbed canine formations. Multiply across a field. Wrap around a mountain. He spits out a thick blob on the large mass of papers scattered over Hands Receivers' trembling body, dissolving, welding, and riveting all at the same time into a spinning volcanic unity, what he always fondly referred to as the Pompeiing stage. All glued hot in acid melt packaging. Throw it back at the roof, the mummy-cocoon ball game. Now pre-emptively aware of the change in pace, Matter jumps to the nearest wall, giving way so as not to interrupt that package of his own making, zooming toward him like a large bullet. Spit when gushing out of the mouth has no surface; it is just

rippled, sticky, or smooth, although when collected into a rotting nostril, it suddenly accumulates surfaces, rising in height. A whole colony of bacteria sets up cities, reproducing dying feeding sleeping on it. Glistening fungal weddings. Dripping some unknown slime, the cocoon sticks to the ceiling. Duur Matter slowly walks out of the Foundation, lighting a cigar, satisfied at the crisp closure of his mission. The computers explode upon contact with his tongue, its glassy hair piercing the chips and all the plastic coating in a single crackling exploding sweep. Crunching electronica feels like a swarm of roasted bees; he swallows them with delight. The Foundation 2 premises were devastated to maggot perfection, he observes, lounging about. In fact, at this rate, one may even come to the formal conclusion that bodies do not even exist—we only have access to a portion of their surface at any given point in time. The dripping cocoons hang like juicy chandeliers above, reminding him of the majestically eerie arrangement of the whales sleeping under the sea. The high ceiling almost appears custom designed for this exquisite moment. He hasn't yet mastered the fabrication of shadows, those strange objects without predictable edges, surfaces, or boundaries. That is the most difficult part. Sometimes his fleshy recompositions have imprecise shadows, off-sync and skewed, not exactly matching the photon exchange rates. Chipping corners, slow buffers. Nevertheless, light had always given him a sense of comfort; only because of its speed, really. Very soon he would learn to move just as fast. But a thick smell of burnt flesh lingers about. Sure this is a good sign; it means things are going well. Like the shifting texture of sand under his feet, the salty scent of sea around, and these evergreen windy evenings of Goa. It was time to light another cigar.

Dear Savitri

Contemplating these glorious Himalayan peaks, I fear I have little to no words that may offer you comfort. But remember, each chillout sunset carries within it a radioactive vibe, as we hang out by the warm glow of this faraway nuclear explosion. The distance makes it golden, romantic, and sweet in its luminous contamination of our Earthly vacation.

In memory of arachnid fallouts...

nicholas.rorix

PLUNDERSAMPLING

THE FIRST NUMBER REFERS TO THE PAGE, THE SECOND TO THE LINE ON WHICH THE QUOTATION ENDS

TERRIBLE MAPS

26, 09 Attributed to Thelonious Monk.

28, 30 Hidetoshi Takahashi, *Oumu kara no kikan*, quoted in Rich Gardner, "Aum Shinrikyo and a Panic about Manga and Anime," in *Japanese Visual Culture: Explorations in the World of Manga and Anime*, ed. Mark W. MacWilliams (London: Routledge, 2008), 209.

29, 25 Risaku Kiridōshi, "Omae ga jinrui o koroshitai nara," quoted in Gardner, "Aum Shinrikyo and a Panic about Manga and Anime," 209.

30, 29 Gustav Demelius, "Ueber fingirte Persönlichkeit," quoted in Stefan Andriopolous, *Possessed: Hypnotic Crimes, Corporate Fiction, and the Invention of Cinema*, trans. Stefan Andriopoulos and Peter Jansen, Cinema and Modernity (Chicago: University of Chicago Press, 2008), 46.

30, 34 Gierke, *Die Genossenschaftstheorie und die deutsche Rechtssprechung*, quoted in Andriopolous, *Possessed*, 48.

31, 01 Otto von Gierke, *Deutsches Privatrecht*, vol. 1, *Allgemeiner Teil und Personenrecht*, quoted in Andriopolous, *Possessed*, 48.

31, 03 Keiko Ihara, "Kyotsugo wa SF Anime da," quoted in Gardner, "Aum Shinrikyo and a Panic about Manga and Anime," 211.

31, 12 Hiroki Azuma, *Otaku: Japan's Database Animals*, trans. Jonathan E. Abel and Shion Kono (Minneapolis: University of Minnesota Press, 2009), 34.

CREATURE SYNTAX

43, 08 Roberto Calasso, *Ardor*, trans. Richard Dixon (London: Allen Lane, 2014), 50.

44, 31 Robert Musil, "Monuments," quoted in Michael Taussig, *Defacement: Public Secrecy and the Labor of the Negative* (Stanford, CA: Stanford University Press, 1999), 52.

44, 37 Jalal Toufic, "The Threshold of No Return," in *Forthcoming*, 2nd ed. (Berlin: Sternberg, 2014), 15.

45, 03 Bram Stoker, *Dracula*, rev. ed. (London: Penguin Books, 2007), 21.

48, 21 Taussig, *Defacement*, 3.

48, 23 Taussig, *Defacement*, 3.

48, 24 Thomas Elsaesser, "Dada/Cinema?," quoted in Taussig, *Defacement*, 3.

49, 03 Rosalind E. Krauss, *The Optical Unconscious* (Cambridge, MA: MIT Press, 1993), 156.

52, 06 Taussig, *Defacement*, 3.

54, 03 Taussig, *Defacement*, 3.

THE INCREDIBLE VEDIC CHILL OR A FOUL LUMP IN THE (ANT)ARCTIC

61, 17 J. G. Ballard, *The Atrocity Exhibition* (London: Fourth Estate, 2014), ebook.

MOLD OF A DANK CONSPIRACY

85, 15 C. L. R. James, in collaboration with Raya Dunayevskaya and Grace Lee, *State Capitalism and World Revolution* (Chicago: Charles H. Kerr, 1986), xxxii.

86, 04 China Miéville, "M. R. James and the Quantum Vampire," in *Collapse: Philosophical Research and Development*, vol. 4, ed. Robin Mackay (Falmouth, UK: Urbanomic, 2008), 124.

86, 19 Frank Norris, *The Octopus: A Story of California*, quoted in Lisa Siraganian, *Modernism and the Meaning of Corporate Persons, Law and Literature* (Oxford: Oxford University Press, 2020), 43.

86, 31 Joseph Conrad, *Heart of Darkness*, quoted in Andriopolous, *Possessed*, 61.

86, 33 Conrad, *Heart of Darkness*, quoted in Andriopolous, *Possessed*, 61.

87, 11 Daniel Schenkel, *Christliche Dogmatik* [Christian dogmatics], quoted in Andriopolous, *Possessed*, 51.

88, 02 Elias Canetti, *Crowds and Power*, trans. Carol Stewart (New York: Continuum, 1981), 17.

90, 04 William Allen Rogers, "The Forty T—, [Thieves]: Baba Jonathan: I don't like your looks, Mr. Merchant, you had better move on," original drawing for cartoon published in *Harper's Weekly*, March 17, 1888, Library of Congress Prints and Photographs Division, Washington, DC, reproduced in Siraganian, *Modernism and the Meaning of Corporate Persons, Law and Literature*, 59.

92, 07 Joseph Conrad's *Heart of Darkness* (1902), quoted from memory.

97, 34 Circular, "Historial," quoted in A. M. Gittlitz, *I Want to Believe: Posadism, UFOs, and Apocalypse Communism* (London: Pluto, 2020), 156.

101, 11 Heinrich Heine, *Confessions*, quoted in Robert C. Solomon, *From Hegel to Existentialism* (Oxford: Oxford University Press, 1987), 58.

APART FROM THE SAMPLED FRAGMENTS ABOVE, MANY BOOKS, ARTICLES, ONLINE POSTS, AND ESSAYS SERVED AS REFERENCES AT VARIOUS STAGES OF THE BOOK. SOME OF THESE, IN NO PARTICULAR ORDER, ARE:

William R. Pinch, *Warrior Ascetics and Indian Empires* (Cambridge: Cambridge University Press, 2012).

Sianne Ngai, *Ugly Feelings* (Cambridge, MA: Harvard University Press, 2007).

Yuk Hui, "The Unhappy Consciousness of Neoreactionaries," *e-flux journal*, no. 81 (2017).

Peli Grietzer, "Theory of Vibe," *Glass Bead* (2017).

Elizabeth Sandifer, *Neoreaction a Basilisk: Essays on and around the Alt-Right* (Monee, IL: Eruditorum, 2017).

Nick Land, *Fanged Noumena* (Falmouth: Urbanomic, New York: Sequence, 2011).

Shuja Haider, "The Darkness at the End of the Tunnel: Artificial Intelligence and Neoreaction," *Viewpoint Magazine*, March 28, 2017.

Carol Schaeffer, "Alt-Reich," *Caravan*, December 31, 2017.

Sven Lütticken, "Toward a Terrestrial," *e-flux journal*, no. 103 (2019).

Nicholas Goodrick-Clarke, *Black Sun: Aryan Cults, Esoteric Nazism, and the Politics of Identity* (New York: New York University Press, 2002).

Dale Beran, *It Came from Something Awful: How a Toxic Troll Army Accidentally Memed Donald Trump into Office* (New York: All Points Books, 2019).

Graham St. John, *Rave Culture and Religion* (London: Routledge, 2009).

Akshaya Mukul, *Gita Press and the Making of Hindu India* (Noida: HarperCollins Publishers India, 2017).

Henri Laborit, "The Biological and Sociological Mechanisms of Aggressiveness," in *Violence and Its Causes* (Paris: UNESCO, 1981).

MOCHU

Mochu works with video and text arranged as installations, lectures, and publications. Technoscientific fictions feature prominently in his practice, often overlapping with instances or figures drawn from art history and philosophy. Recent projects have explored corporate horror, mad geologies, psychedelic subcultures, and Indian modernist painting. Mochu is the author of the book *Nervous Fossils: Syndromes of the Synthetic Nether* (2022), and he is a recipient of the Edith-Russ-Haus Grant for Media Art (2020–22). His works have been supported by Ashkal Alwan, India Foundation for the Arts, and the Sarai Programme and exhibited at the 9th Asia-Pacific Triennial, Brisbane; Sharjah Biennial 13; 4th Kochi-Muziris Biennale; Alserkal Avenue, Dubai; Kiran Nadar Museum of Art, New Delhi; and transmediale: "BWPWAP", Berlin.

ACKNOWLEDGMENTS

Bits of the text appeared previously in my video *GROTESKKBASILISKK! MINERAL MIXTAPE* (2022), realised in the context of my solo exhibition "Sentient Picnic" at the Edith-Russ-Haus for Media Art, as part of the Foundation of Lower Saxony Grant for Media Art.

I would like to thank Edit Molnár and Marcel Shwierin, Co-directors of the Edith-Russ-Haus, for their openhearted patience and support, through every stage of the making of this book as well as the video work and exhibition that preceded it. Comments and reviews by Merve Ertufan, since the earliest drafts, were indispensable to the way the book has turned out, along with the insightful suggestions by Priyanka Chhabra, Emre Hüner, and Suvani Suri at different stages of the text in formation. I would like to thank Jaclyn Arndt for her precise and careful edits of the manuscript, as well as the entire team of Squadron 14 for the effort and detail put into developing an imaginative design language and cover image that resonates with the text.

MOCHU
BEZOAR DELINQXENZ

Edited by Edit Molnár and Marcel Schwierin
Coordination: Edit Molnár, Ulrich Kreienbrink
Copyediting and Proofreading: Jaclyn Arndt
Graphic Design: Squadron 14
Images: Mochu from *GROTESKKBASILISKK! MINERAL MIXTAPE*, 2022
Cover Image: Squadron 14
Print Management: Katarina Ševic
Production: Edith-Russ-Haus for Media Art
Printing and Binding: Druckhaus Sportflieger
Photo Editing: Katarina Ševic

Published on the occasion of the exhibition
"Mochu—Sentient Picnic"
April 28, 2022–June 12, 2022
Curated by Edit Molnár and Marcel Schwierin

Supported by:

MOCHU
BEZOAR DELINQXENZ

ISBN: 9783956796531

© 2022 the artist, the author, the editor, Sternberg Press, Edith Russ Haus
All rights reserved, including the right of reproduction in whole or in part in any form.

Distributed by The MIT Press, Art Data, Les presses du réel, and Idea Books

Every effort has been made to contact the rightful owners with regards to copyrights and permissions. We apologize for any inadvertent errors or omissions.

The Deutsche Nationalbibliothek lists this publication in the Deutsche Nationalbibliografie; detailed bibliographic data is available online at http://dnb.dnb.de.

Published by:

Sternberg Press
71–75 Shelton Street
London WC2H 9JQ
United Kingdom
www.sternberg-press.com

edɪth
russ
H A U S
for Media Art

Edith-Russ-Haus for Media Art
Katharinenstraße 23
26121 Oldenburg
Germany
www.edith-russ-haus.de